The Manual of Interior Photography

Michael G. Harris

Focal Press
An imprint of Butterworth-Heinemann Ltd
Linacre House, Jordan Hill, Oxford OX2 8DP

ℛ A member of the Reed Elsevier group

OXFORD LONDON BOSTON
MUNICH NEW DELHI SINGAPORE SYDNEY
TOKYO TORONTO WELLINGTON

First published 1993

British Library Cataloguing in Publication Data
Harris, Michael G.
 The Manual of Interior Photography
 I. Title
 778.7

ISBN 0 240 51296 0

Library of Congress Cataloguing in Publication Data
Harris, Michael G.
 The Manual of interior photography/Michael G. Harris.
 p. cm.
 Includes bibliographical references and index.
 ISBN 0 240 51296 0
 1. Photography of interiors. I. Title.
 TR620.H37 1993
 778.9'4–dc20 92–41310
 CIP

Front cover. The Octagon Room,
Basildon Park, Berkshire (National
Trust)

Composition by Genesis Typesetting, Laser Quay, Rochester, Kent
Printed and bound in Spain by Printeksa

Contents

Preface xi
Acknowledgements xiii

Introduction 1
Lighting 1
Composition 1
Technique 4

1 Cameras and lenses 5
Introduction 5
Cameras 5
Camera movements 8
Shift movements 8
Scheimpflug adjustments 11
Extra camera facilities 12
Lenses 12
Lens testing 12

2 Ancillary equipment 15
Introduction 15
Filters 15
Colour correction filters 15
Colour compensating filters 17
Filter mounts 18
Lighting 19
Flash 19
Tungsten 22
Colour correction filters for tungsten 23
Meters 23

Light meters 23
Flash meters 24
Colour-temperature meters 24
Tripod 24
Necessary extras 25

3 Film and materials 27

Introduction 27
Film 27
Storage 28
Colour transparency film 29
Colour negative film 30
Black-and-white film 31
Instant-print film 32
Leaving for the shoot 33

4 Approach 35

Introduction 35
Composition 36
Symmetry 36
The Law of Thirds 36
Spatial values 37
Dynamics of composition 38
Individual interpretation 38
Frame positioning 40
Styling 40
Detailing 40
Lighting 41
'Fill-in' lighting 41
Placement of lights 42
Strength of 'fill-in' 43
Different requirements for different clients 44
Detail shots and continuity 44

5 Technique Part 1: The practical everyday method 47

Introduction 47
Lens selection 48
Lighting 48

Focusing 50
Film 50
Flash/light metering 50
Evaluation of lighting ratio variants 51
Instant-print assessment 52
Exposure trials 52
Image construction 53

6 Technique Part 2: The critical precision method 55

Introduction 55
Film 55
Focusing 55
Universal Depth of Field Table 56
Universal Depth of Field calculators 57
Multiple flash and multiple exposure 57
Exposure calculation between instant-print and transparency
films of different speeds 57
Exposure/flash trials 59
Checking colour balance 59
Professional etiquette and insurance 60

7 Mixed lighting conditions 61

Introduction 61
Part 1: Mixed daylight and tungsten 61
Part 2: Mixed tungsten and fluorescent 64
Part 3: Mixed fluorescent and daylight 65

8 Problem interiors 67

Introduction 67
Large interiors 67
Available light 67
Hidden flash lighting 68
'Painting with light' 69
Clip testing 72
Small interiors 73
Empty interiors 74
No electricity 76
Reflective surfaces 76
Poor daylight 78
Staircases and stairwells 79

9 Extra effects 81

Introduction 81
Balancing interior and exterior light to show external view 81
Creating a night scene 82
Highlighting 83
People in interiors 84
Illuminating fireplaces 86
Creative angles 88

10 Presentation 89

Introduction 89
Editing 89
Film damage 92
Mounting 93
Presentation to client 95
Portfolio 96
Storage 97

Bibliography 99
Index 101

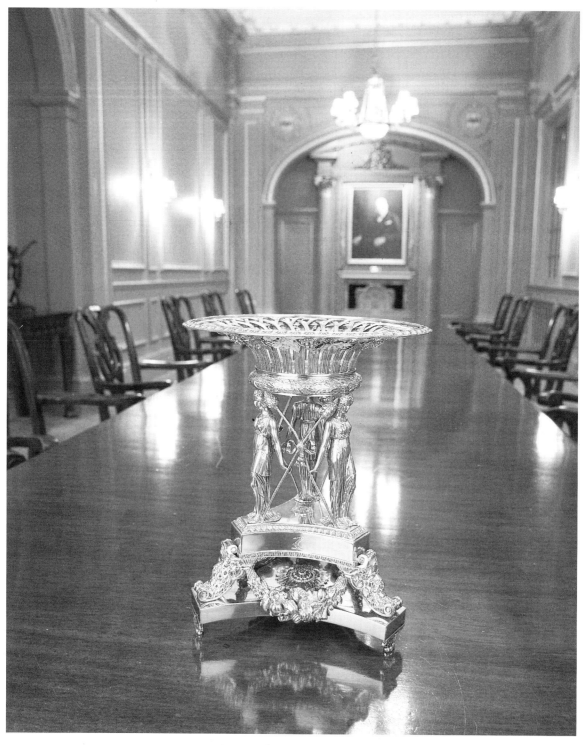

Figure P.1 A silver fruit stand (by silversmith Paul Storr, 1812) elegantly portrayed in the boardroom of the Company of Cutlers in Sheffield. Taken to illustrate a magazine feature on the Company, this photograph is an example of how an interior can be successfully used as a product setting

Preface

Interiors are often the product of years of meticulous architectural planning and interior designs, be they residential, communal or commercial. Their artistic interpretation has had a long historical tradition, perhaps best exemplified by the Dutch Masters of the seventeenth century. This tradition shows the change in contemporary fashions of interior design alongside the corresponding progress through the ages of social, economic and technological development.

The art of interior photography is to capture on film the essence of an interior as an aesthetic concept, through recording the interplay of available light and shade with the proportions and furnishings of a room. Before the days of electric or gas lighting architects specifically designed interiors around available window light. Modern architects are more likely to design around a combination of natural and artificial lighting, but with equal intensity of consideration to the overall aesthetic concept.

The passion for interior photography comes from the thrill of discovering that essence, and then expressing what is a three-dimensional atmospheric experience to its best advantage on a mere two-dimensional sheet of film.

Commercial photographers inevitably have to photograph interiors to some extent or other, if only as a backdrop for a model or product setting. Considering this, there has been pitifully little technical information available on interior photography, and certainly disproportionately few publications for the amount of interior photography commissioned. There are plenty of excellent high-quality picture books and specialist magazines featuring every kind of interior, but a dearth of technical publications on the subject. The idea of this book is that it will start to bridge that gap.

My hope is that this book will be both a practical tool and a useful reference work for photographers. In acknowledgement of those already working in the field of interior photography, I trust it will yield a greater understanding of the lengths to which photographers have to go to create perfect interior photographs.

Finally, this is a specialist text specifically on interior photography, so it assumes a general understanding of the basics of photographic theory.

Michael G. Harris

Acknowledgements

I would like to thank the following people for their assistance in making this book.

Firstly, my commissioning editor, Margaret Riley, for her positive response to my initial approach, and for her enthusiasm and encouragement throughout. John Saunders, Terry Cross and all the staff of Cascade Colour Services for many years of consistent high-quality processing and printing as well as their ever-willing friendly service.

My clients for sourcing much of the material in this book, and also my family and friends who have kindly allowed me to photograph their churches and homes. Simon Hayter who kindled my passion for photography in the first place; and Chris Warde-Jones, wherever he may be, whose photographic genius and friendship inspired me further towards professional photography. And finally, my wife Val and young son Leo who gave me the space and encouragement to make this possible.

All the photographs in this book were taken by the author unless otherwise specified.

Introduction

Figure I.1 overleaf is a typical photograph of an interior. It appears naturally lit, simply composed, in fact precisely the view you might imagine would confront you on entering the room. In other words, a straightforward record of the interior as it was found, involving little specialist technique at all.

Such satisfying deception is usually the mark of a successful photograph. For such an interior to appear on film as the naked eye would interpret it, much subtle composition, styling and lighting has to be employed, calculations made, and technical decisions taken. Turning the next few pages will start to reveal these subtleties, unveiling some of the concealed layers of technical and artistic construction necessary for creating such a photograph.

Lighting

The lighting for Figure I.2 was actually a combination of natural daylight and two flash units bounced off white umbrellas placed strategically between the camera and the windows, as shown in Figure I.2. The flash is necessary because the contrast between the light and shade areas of the interior would have been too great to record on film, despite being readily discernible to the eye. The light areas would have 'burnt out' and the shadow areas would have been recorded as a black void.

Composition

Construction

Figure I.3 shows that the image has been composed more or less according to the Law of Thirds, a universally appealing approach to composition whereby the main subject(s) are positioned on or near an intersection of the thirds, as demonstrated. It also includes the most significant elements of the room, and by showing at least two walls indicates the spatial qualities of the interior.

Dynamics

Figure I.4 demonstrates how the image has been deliberately designed for maximum dynamism of the lines created within the composition of the image: to cut the borders at oblique and conflicting angles for a graphically punchy shot.

Figure I.1

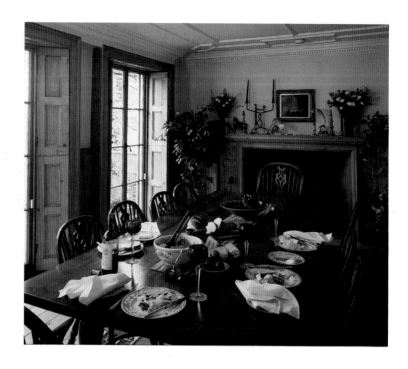

Figure I.2

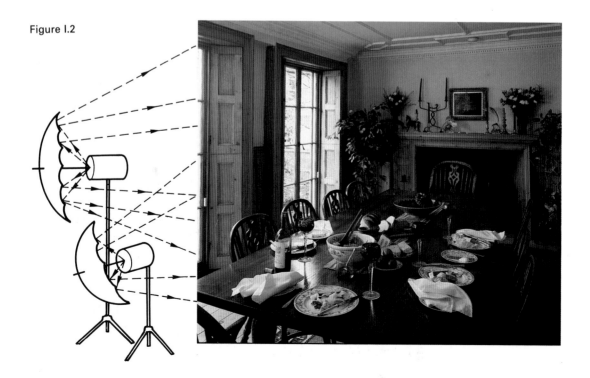

Figure I.3

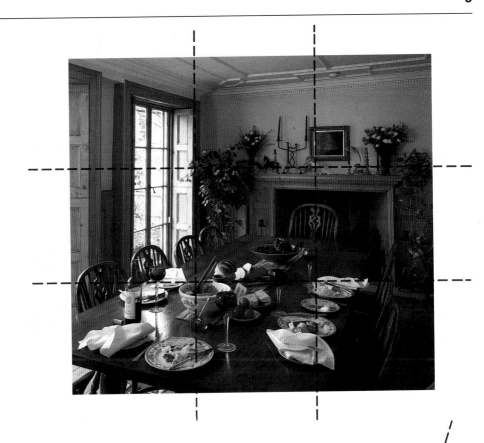

Figure I.4

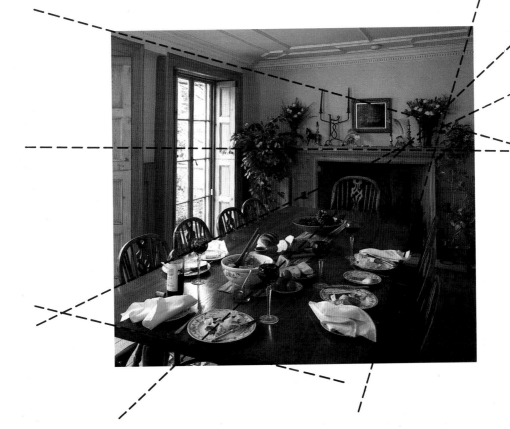

Technique

Further technical questions need to be answered and choices made. What film-format, what type of camera and lens is best suited to shoot such a photograph? What type of film would you use? If working on colour transparency film, is it best to use a daylight-balanced or a tungsten-balanced film? What working aperture is necessary to ensure all elements in the picture are perfectly in focus, while retaining optimum lens performance? What ratio of ambient to flash light will give us the desired natural appearance in the final image?

The questions about equipment and film have to be answered first before examining the artistic and technical methods involved in shooting the actual photograph. The first three chapters concentrate on these necessary preliminaries.

1
Cameras and lenses

Introduction

There is a huge variety of cameras and accessories available on the photographic market. Initially the choice seems exciting but daunting, especially since making the wrong choice could prove to be very costly. Unfortunately, there is no single camera that is the perfect choice for all photographic requirements. So either you specialize and restrict the kind of work you undertake to that which is possible with the camera you have chosen; or you purchase several different types of camera to cover all the requirements that are likely to be asked of you.

For general commercial work, photographers tend to switch between a monorail camera, with its extensive viewcamera adjustment facilities; a medium-format SLR camera, for people and action when it is essential to see through the camera lens at the moment of exposure; and 35 mm SLR cameras for their portability, speed, and ease of use.

This book is specifically about interior photography so choice of equipment is immediately restricted.

It is important to stress that it is a false economy not to buy the very best equipment you can possibly afford, even if this means taking out a loan to do so. There are two reasons for this. First, the best equipment (usually the most expensive) does produce the best results. Even if you are unaware of the difference in quality now, it does not take long to become acutely aware of that difference. Second, it is essential to familiarize yourself with your camera as soon as possible (which only comes through experience) so that its usage becomes second nature. The distraction you do not want is having to concentrate more on setting up the camera (from repeatedly having to upgrade your system) than on the subject of the photograph.

Apart from these two fundamental reasons, the better the equipment, the more it retains its second-hand or collectable value should you ever want to sell it.

Cameras

For high-quality interior work, 35 mm cameras are largely unsuitable. Their small film size renders a poorer image quality than the larger formats, and makes perfect image construction difficult. They are also less practical because they lack the facility of interchangeable film backs, most importantly the instant-print magazine back.

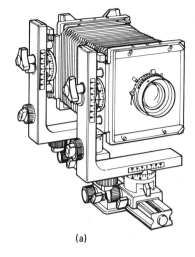

(a)

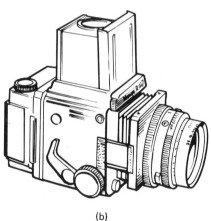

(b)

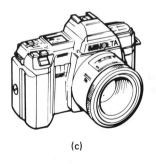

(c)

Figure 1.1 Three basic camera types used in general commercial work. (a) The monorail viewcamera; (b) the medium-format 120 roll film single-lens reflex camera; (c) the 35 mm single-lens reflex camera. Each type has different characteristics suitable for different kinds of work, and no single camera is ideal for all photographic requirements

It is essential to be able to fit an instant-print magazine back to the camera you choose. It enables you to take an instant picture of the precise image that will appear on film, which you then use to check the composition, the balance of lighting, the exposure and any unwanted flash reflections that may have been elusive to the naked eye. The peace of mind that instant-prints give the photographer cannot be overstated. Through experience again, you learn how to 'read' the instant-print image in terms of contrast and exposure. After making the necessary lighting and exposure changes, you can then take a further instant-print to check that those changes have produced the result you desire. Taking two instant-prints at different exposures also gives you an immediate indication of the actual effect on the image of the different exposures be they, for example, a half- or full-stop apart.

The next choice, having eliminated the option of 35 mm cameras, is whether to buy a medium-format camera (which takes 10 or 12 exposures on 120 film, with an image size of 6 × 7 cm or 6 × 6 cm respectively) or a large-format viewcamera that takes individual sheets of film, typically 5 in × 4 in or 10 in × 8 in. The larger the format, the smaller the depth of field for a given aperture, and therefore the greater the output of light needed to retain complete sharpness throughout the depth of the picture.

The advantage of the large-format viewcamera is obviously its higher picture quality, and the use of its extensive camera movements. However, for the most uses, this extra clarity in picture quality is unwarranted, and in a typical A4-sized publication could not be told apart from its medium-format equivalent on the printed page. There is no doubt, though, that if the photos are to be enlarged to billboard poster proportions, then the large format would definitely produce a sharper result.

The great disadvantage of the large-format camera, apart from its own extra weight and bulk, is the extra ancillary equipment it necessitates: more powerful (and therefore heavier) lighting equipment, the heaviest and sturdiest possible tripod, a changing bag for loading film, etc. The film and processing costs per shot are obviously much higher, and you do not have the facility for bracketing exposures which, for critical lighting on interiors, gives the client or editor a greater choice of lighting effect for the publication. While it is possible to 'read' a lot from an instant-print, it is not a perfect image, so exposure variations are the simplest way of achieving an appropriate choice on film.

The medium-format camera, however, with 10 or 12 exposures per film, does enable the photographer to bracket the exposures all on one film. The extra image quality over 35 mm, the instant-print magazine back facility on most medium-format cameras, and the modest light output needed to ensure sufficient depth of field in the photograph, all make the medium-format camera the ideal choice for interior work.

There is, of course, a great variety of medium-format cameras available and again the choice must be made in accordance with the usage you will be demanding from it. There are two main categories of medium-format cameras: single-lens reflex (SLR) cameras and viewcameras.

The SLR cameras, epitomized by the Hasselblad range, are suitable for most interior situations. Their 6 × 6 cm format is favoured by some magazine picture editors who find a square format the most adaptable for cropping. While they are very popular and widely used, their main disadvantage is the low camera position that is often needed when photographing interiors, to avoid showing too much ceiling and not enough of the foreground, while retaining the verticals in the picture.

In order to avoid the common problem of diverging verticals in interior photography, it is essential not to tilt the film-plane of the camera. The low position that has to be adopted can appear unnatural in comparison with the standing-height view that we are used to in everyday life. Objects on tables can also appear very oblique.

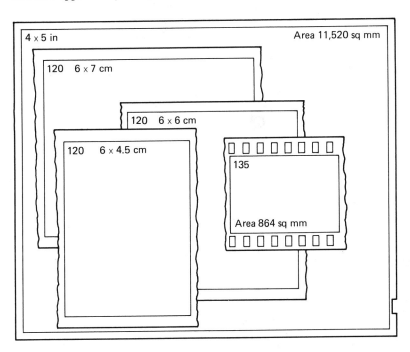

Figure 1.2 A comparison of the actual frame sizes of the different film formats readily available

Some of these SLR cameras, including the Hasselblad range, can be fitted with a shift lens to overcome this problem to an extent. Shift lenses, also known as 'perspective control' (PC) lenses, are specially designed to enable a limited amount of the shift movements (described in the next section) on an otherwise fixed camera body. However, these lenses are usually extremely expensive and not very wide-angle, thereby restricting the image to the focal length available.

Medium-format viewcameras, on the other hand, have all the movements and adjustments of a large-format camera, plus the versatility and bracketing ability of the medium-format camera. Epitomized by the Linhof Technikardan range, this is the ideal camera type for interior work. You have the flexibility of camera movements with lenses of all focal lengths, which is also perfect for exterior architectural work, where control over converging verticals is of paramount importance. Such a consideration is sensible as many assignments for interior work include some exterior shots as well. It would therefore be prudent to consider exterior architectural usage when making your choice of camera.

The use of any type of viewcamera is, however, more complicated than an SLR, and this should be borne in mind as a factor by the less experienced photographer. Picture composition can be difficult until you are familiar with the camera, as you are dealing with an inverted image on the ground glass focusing screen. You also need an independent magnifier to achieve perfect focus, with a photographer's black cloth over your head and around the focusing screen to shield it from the surrounding light. You

Figure 1.3 A shift, or perspective control (PC), lens. This enables a limited amount of shift movements on a regular SLR camera. Choice of focal length, however, is very restricted

can avoid this by using a monocular viewfinder (which will also partially correct the image inversion) but this will make an already fairly dark image even darker. This is especially significant in interior photography when light levels are typically much lower than in outdoor work.

The viewcamera can only be used mounted on a tripod – which would also be true of any camera used for the long exposures demanded by interior photography – and the focusing screen has to be replaced by the appropriate film back before you take a photograph. This, therefore, makes it impossible to view the image up to the precise moment of exposure that is possible with an SLR. Hence its use is restricted when photographing people in interiors, or if there is any unpredictable movement likely within the picture area. In such circumstances, the SLR would be the better choice. To have both camera types available would give you the greatest flexibility.

Camera movements

The camera movements on a viewcamera are divided into four categories: rising shifts, cross shifts, swings and tilts. The first two are generally known as shift movements (as might be expected!), and the latter two are known as Scheimpflug adjustments. Each individual movement can be carried out on the front standard that holds the lens panel, the back standard that holds the focusing screen, or both, depending on the results you want to achieve within the limitations of the covering power of the lens.

Within the realm of interior photography, the two shift movements are the most widely used, though there are also uses for some Scheimpflug adjustments in exceptional circumstances.

Shift movements

Shift movements are parallel movements of the front and/or rear standards. Rising shifts are shifts in the vertical plane and are used to eliminate converging verticals in exterior architectural work, or diverging verticals in interiors. The lens panel remains parallel to the focusing screen and is shifted either up or down from its neutral, central position.

This allows the focusing screen, and therefore the film back, to remain perfectly vertical, which is the essential requirement for perfect verticals in the recorded image. It means that if there is too much ceiling in the image of an interior when viewed from eye level with the film back vertical, the film back or lens panel can be shifted either up or down respectively to include more foreground and less ceiling. This avoids having to tilt the camera downwards, causing the verticals to start to diverge, or having to lower the height of the camera to an unnaturally low elevation, see Figure 1.6. While exaggerated converging or diverging verticals can add dramatic effect to a creative shot, slight convergences or divergences merely jar with the perfect verticals of the photograph edge and the printed page.

Cross shifts are shifts in the horizontal plane and, while not used with quite the frequency of rising shifts in interior photography, are still invaluable for certain specific types of shot. Most commonly, cross shifts are renowned for their magical ability to photograph a mirror (or other highly reflective surface) from an apparently parallel, head-on position, without the image of the camera being reflected in it. This is because the

Figure 1.4 The shift movements available on a viewcamera are parallel movements of the front and/ or rear standards. Rising shifts are shifts in the vertical plane, and cross shifts are shifts in the horizontal plane

camera is not directly in front of the mirror but actually just to the side of it. In fact, only the lens has been shifted sideways, to include a part of the image that is within the range of the image circle of the lens, but is not normally included in the area of the focusing screen when all movements are neutrally centred.

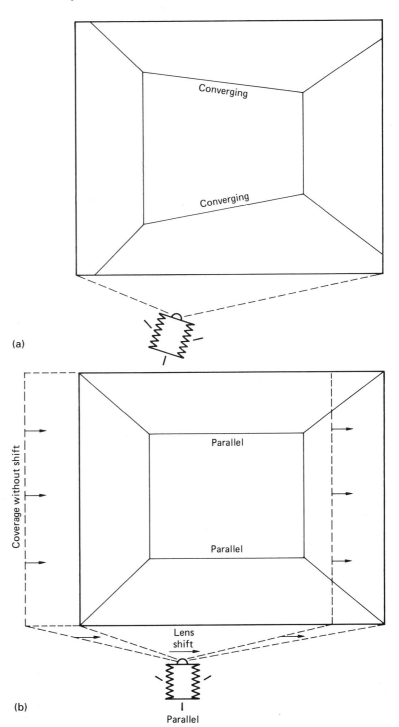

(a)

(b)

Figure 1.5 Diagram (a) shows a typical fixed lens view of an interior. The camera back is out of parallel with the far wall (to include the desired scope of the interior), causing convergence of the horizontal lines of that wall. While this is visually acceptable in itself, for the purposes of a clean architectural shot, the camera back can be made parallel with the wall. A cross shift of the lens is then used, which corrects this horizontal perspective distortion, as in diagram (b)

This facility can be used in interiors either for detail shots of reflective subjects within the interior or if camera positioning is restricted. A cross shift of the lens can be the only way to include all the necessary elements of an interior from an angle that the photographer cannot naturally achieve.

Figure 1.5 shows how cross shifts have a further use in perfecting the horizontal lines of an interior, in just the same way that rising shifts prevent the convergence or divergence of verticals. As soon as the film plane ceases to be horizontally parallel to the back wall in a rectangular interior, the horizontal lines of the far wall in the picture will start to converge or diverge horizontally as a result of natural perspective. While such horizontal perspective 'distortions' are much more visually acceptable than vertical 'distortions', a cleaner, architecturally perfect image can be produced if you correct them too. Within the limitations of the lens you can use a combination of both rising and cross shifts to achieve desired results. These limitations become quite apparent through experimentation on an instant-print when a black arc cuts off a corner of the image.

Figure 1.6 These four photographs together demonstrate the main benefit of rising shifts in interior work. Photograph (a) shows the problem of photographing an interior from eye-level with a fixed lens on an SLR: to retain perfect verticals the camera cannot be tilted, so too much ceiling appears in the image. Photograph (b) shows how the verticals diverge if the camera is tilted to include more foreground. The other alternative is to shoot from a lower elevation, as in photograph (c). This, though, can sometimes appear unnatural with objects on tables being shot at an oblique angle. However, we have got used to seeing interiors shot from this low elevation, for the reasons described above. The most effective solution is to use a viewcamera, enabling a simple vertical shift of the lens panel or film plane to include more of the foreground and less of the ceiling – see photograph (d)

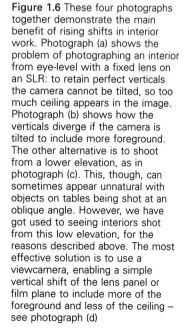

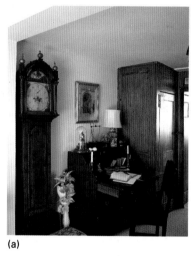
(a)

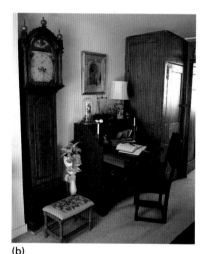
(b)

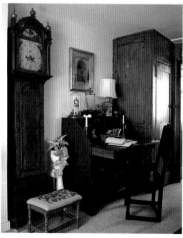
(c)

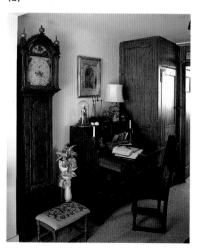
(d)

Scheimpflug adjustments

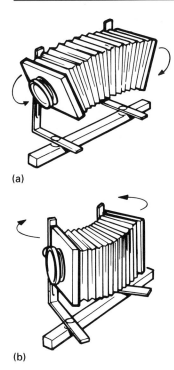

(a)

(b)

Figure 1.7 The Scheimpflug adjustments available on a viewcamera are swing and tilt movements. The lens panel or focusing screen, or both, are either swung around a vertical axis (a) or tilted over a horizontal axis (b). This alters the plane of focus, and can thereby increase the depth of field along one plane

Scheimpflug adjustments are the swing and tilt movements on a viewcamera. The lens panel or the focusing screen, or both, are either swung around a vertical axis or tilted over a horizontal axis in order to control the plane of focus, and thereby the depth of field, in exceptional circumstances.

In interior photography, swings are usefully employed for some detail shots: a wall or piece of furniture photographed close up from a horizontally oblique angle, for example. Without any movements, even with the smallest available aperture and an abundant light output, it might still be impossible to get both the foreground and the background in focus at the same time. However, by swinging the lens around the vertical axis a few degrees so that the subject plane, the focal plane (i.e. the focusing screen/film back plane), and the lens panel plane all intersect at an imaginary common line, you will maximize the depth of field along the subject plane.

According to the Scheimpflug principle, it theoretically makes no difference whether the front or rear standards, or a combination of the two, are adjusted, so long as the three planes intersect at a common line. Practically speaking, however, it does make a difference. Swinging the lens panel is limited by the covering power of the lens, and any movement of the camera back alters the perspective to a degree, especially of the foreground subjects.

If maintaining the perspective is of paramount importance, then swinging the lens panel alone is the best way to increase depth of field. If precise perspective is not an issue, the way to achieve maximum depth of field along the oblique subject plane with maximum lens coverage and minimum lens distortion is to swing both the front and rear standards around the vertical axis equally, but in opposite directions, with the three planes still intersecting at an imaginary common line.

Tilts work in precisely the same way as swings, except around a horizontal axis, as the name suggests. This means that they would be perfect for altering the plane of focus to increase the depth of field across an empty floor: the foreground and the background could be perfectly in focus at a relatively wide aperture. However, such instances are rare in the world of interior photography.

Scheimpflug adjustments can only control depth of field across one specific plane of focus. Apart from some detail shots, the depth of field required in most interior photography is fully three-dimensional, making

Figure 1.8 The Scheimpflug Principle for maximizing depth of field. The film plane, lens plane and subject plane must all intersect at an imaginary common line, with an equal swing on both the front and rear standards

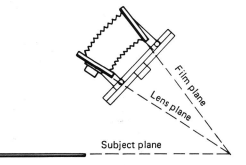

Film plane

Lens plane

Subject plane

Scheimpflug adjustments fairly useless. There would be no point in having the full depth of the floor in focus if all the furniture any height above it was out of focus.

So the best way to achieve depth of field throughout the full three dimensions required for photographing an interior is to reduce the size of the aperture. If that still fails, you would have to use a lens of wider angle to create a smaller reproduction ratio – the smaller an object is reproduced on film, the greater the depth of field around it.

Extra camera facilities

It is ideal if the camera you choose has fitted spirit-levels. These are essential for retaining perfect verticals in your shots. If, however, they are not fitted on the camera you choose it is possible either to buy one that clips into the flashgun accessory shoe (if there is a shoe) or use a free-standing one. The latter has a further use for levelling picture frames on the wall.

It is also sensible to have two film backs, as well as the instant-print magazine back, for several reasons. It gives you the opportunity of shooting the same image on two different film types without having to shoot the whole roll; it covers you in case one back breaks down; it allows you to shoot just a few extra frames of the subject on a separate roll as a back-up in case of processing damage to the original film; or it enables you to work from one back to the next without having to stop and change the film.

Lenses

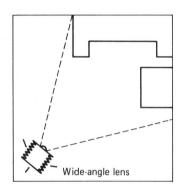

Wide-angle lens

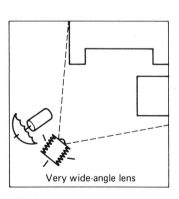

Very wide-angle lens

It is useful to have a reasonable selection of lenses of different focal lengths to enable you to cover the demands made of you in interior and architectural work, and also to make results easier to achieve in awkward situations. For example, such a situation occurs when photographing small interiors. You may just be able to include the desired scope of the interior with a medium wide-angle lens, but only by crushing yourself into the corner of the room and then discovering that there is no suitable place out of camera view to place the flash unit. By using a very wide-angle lens (without linear distortion – see next section) it becomes possible to move a couple of feet out of the corner, placing the flash unit either beside or just behind you, while retaining the full desired picture area.

A practical complement of lenses would include a very wide-angled lens (47 mm on medium format); a medium wide-angled lens (65 mm on medium format); a standard lens (100 mm on medium format); and a short telephoto (180 mm on medium format). A further lens between the medium wide-angle and the standard (a 75 mm or 85 mm, for example) would prove useful for exterior architectural work, as would occasionally a longer telephoto lens, but perhaps it is best to hire the latter on such occasions.

Figure 1.9 The covering power of a very wide-angle lens can be usefully employed to create the extra space needed for both the photographer and any photographic lighting, in a small interior

Lens testing

All serious photographic lenses are compound lenses: a combination of several different lens elements within a single lens barrel. This is because the image quality produced by a single lens element alone is quite

inadequate for photographic purposes. Straight lines (which are obviously critical in any interior or architectural work) become curved, and if the image is sharply focused at the centre of the focal plane, the edges will be blurred. Only by combining several lens elements in a symmetrical configuration can these aberrations best be corrected.

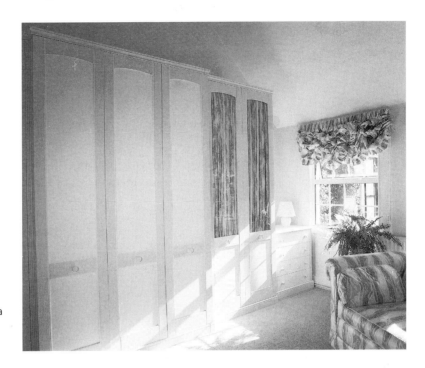

Figure 1.10 This is a fine example of unacceptable linear distortion of a wide-angle lens. The vertical line of the wardrobe along the left-hand side of the image is quite curved

The quality of glass, the precise figuring of the elements, and their accurate spacing within the barrel are all absolutely critical to the performance of the lens. Due to the highly skilled operations involved in lens production, the most expensive lenses are usually the best. This is probably the most important area not to economize, especially with wide-angle lenses (for reasons outlined below). The quality of the lens is the most fundamentally important component in the whole picture-creation process.

That said, most medium-format lenses on the market are of a high standard, and the best are of a very high standard. However, for precision interior or architectural work, they should still be tested critically for any linear distortion (curving of straight lines) at the edges of the image. On the printed page, any curving of supposedly straight vertical or horizontal lines, especially at the edges of the image, becomes very apparent beside the perfectly squared picture and page edges.

I would not expect to find any such linear distortion either on standard focal length lenses or on lenses with longer focal lengths than the standard. The lenses with a natural tendency to this distortion are wide-angle lenses, especially at focal lengths approaching those of a fish-eye lens. The shorter the focal length of the lens, the greater the natural tendency towards linear distortion.

The toughest practical test to put a wide-angle lens through is to photograph a perfectly straight vertical and horizontal line at the outer

limits of the image area. A door frame is a very suitable subject for this test, assuming that it is perfectly aligned.

Shoot the image both vertically and horizontally, top and bottom (place a flat rule across the floor at the bottom if necessary to provide the fourth straight line). This will test the sides, the top and the bottom edges of the lens for their performance with regard to linear distortion.

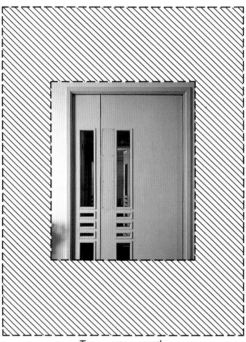

Figure 1.11 A door frame is a suitable subject on which to test wide-angle lenses for linear distortion. A mounting mask is placed alongside the verticals and horizontals of the door frame in the image to check for any curving

Transparency mask

When the film is processed, use a manufactured black mounting mask, with its perfect right angles, to analyse the results on a lightbox. Place the inside corner of the mask very close to the corner of the door frame on the film and visually compare the door frame for any bowing of the straight lines with the straight edges of the mask. These should be apparent to the naked eye on medium format. If any linear distortion is evident you will have to reject the lens in favour of a better one.

2
Ancillary equipment

Introduction

Having chosen a suitable camera and selected an appropriate set of lenses, it is time to turn your attention to the rest of the supporting equipment that is necessary for photographing interiors. Again, it is easy to be dazzled by the vast array of equipment available, and it is therefore important to be clear about the equipment you actually need when starting in this field and that which might be desirable at a later date once you are more experienced and eager to fine-tune your technique. For example, while a pair of photographic lights (probably flash units along with a flash meter) are essential, an independent light meter is unnecessary if you already possess an old 35 mm camera with a built-in light meter. A colour-temperature meter, along with a comprehensive set of colour-compensating filters, is probably one of the last pieces of equipment you would need to buy as its use is very specialized, and not absolutely necessary for most general interior photographic purposes.

Filters

Photographic filters are coloured or textured discs of glass, plastic or gelatin placed in front of the lens in order to modify the colour or quality of light passing through it onto the film-plane, thereby altering or enhancing the recorded image. Filters can broadly be divided into three categories: colour correction filters, colour compensation filters, and special effects filters. Colour correction and compensation filters balance the colour of the light source with the type of film being used, and therefore are of fundamental importance for interior photography. Special effects filters, however, are of limited use.

Colour correction filters

Colour correction filters alter the 'colour temperature' of the light passing through the lens. Therefore they are either a strength of amber, to 'warm' up the light (in the colloquial sense), or a strength of blue to 'cool' it down. They are necessary because while the human eye readily compensates for variations in colour temperature, colour film tends to emphasize it.

The 'colour temperature' scale, in degrees Kelvin, measures the colour of the light radiated by an incandescent light source (i.e. one that glows from being heated) when heated to different temperatures. At the bottom

end of the scale these incandescent light sources include candlelight with a low colour temperature of 1930 K and domestic tungsten lightbulbs with a medium-low colour temperature of 2900 K for a 100 W bulb. Light sources with a low colour temperature radiate colours from deep red, through orange, to yellow and finally yellowish-white. They therefore require blue filtration to correct the balance of their colour temperature to that of photographic daylight. In the middle of the scale is direct noon sunlight, or 'photographic' daylight, at 5500 K: neutral white light in photographic terms to which all general-purpose colour films are balanced.

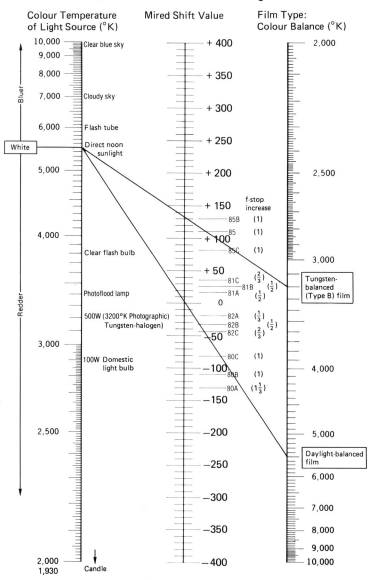

Light Source Conversion Diagram

Figure 2.1 Colour correction filters. Draw a straight line between the colour temperature of a light source on the left and the film type in use on the right. The necessary filter to correct the colour balance is indicated at the point where the line crosses the central scale. This also shows the mired shift value together with the necessary exposure increase in f/stops

(N.B. Exposure increases are given for Hoya filters. Recommended increases vary slightly between manufacturers)

Light sources with colour temperatures higher than 5500 K include sunlight filtered through an overcast sky at between 6000 K and 7000 K, to light reflected from a clear blue sky (in open shade, not in direct sunlight) at between 10,000 K and 15,000 K. These light sources with high colour temperatures radiate colours from bluish-white to blue, and therefore require amber filtration to correct the balance of their colour temperatures to that of photographic daylight.

The effects of colour correction filters are not measured in Kelvins due to the logarithmic nature of the scale which would give the same filtration different values for different source colour temperatures. Instead, they are measured in mired shifts (shifts of MIcro REciprocal Degree i.e. one million divided by the colour temperature in Kelvins). This is a more convenient means for calculating the necessary strength of filtration in order to correct the colour temperature of a particular light source, as it gives the filter a constant value. Thus the colour correction filters for positive mired shifts above zero are strengths of amber (the 81- and 85-series), and for negative mired shifts are strengths of blue (the 80- and 82-series).

For example, using a daylight-balanced film, balanced for white light at 5500 K (a mired value of 1 million ÷ 5500 = 182) with tungsten photographic lighting at 3200 K (a mired value of 1 million ÷ 3200 = 312) the difference and incompatibility between the two is $182 - 312 = -130$ mireds. Reading from the scale in Figure 2.1, a blue 80 A filter would be the appropriate filtration necessary to correct the colour temperature of the light source to that of the film.

Professional colour transparency films are available in a choice of only two different colour balances: daylight-balanced (5500 K) film, the most common, for use when daylight or flash is the dominant light source; and tungsten-balanced (3200 K) film where tungsten light is the primary source. Colour correction filters can be used to balance the colour temperature of particular light sources with the film-type being used, as described in the example above. A more frequent use of colour correction filters is to convert the balance of a daylight film to tungsten, and vice versa. The strong colour correction filters used specifically for this use are known as 'colour conversion' filters.

The 80 A filter (deep blue) will convert a daylight-balanced film for use in tungsten lighting, as in our example; and the 85 B filter (strong amber) will convert a tungsten-balanced film for use in daylight or with flash. This latter conversion is of particular importance because tungsten-balanced film has some special properties for the long exposures sometimes necessary for interior photography. There is further explanation of this both in the next chapter and in Chapter 6.

Colour compensating filters

Colour compensating filters, usually made of thin gelatin, are similar to colour correction filters but are more wide-ranging in the sense that they are available in the six colours of the photographic process: red (R), green (G) and blue (B), and their complementary opposites cyan (C), magenta (M) and yellow (Y), all in varying densities. In combination or alone, these filters can finely tune the colour balance of almost any lighting situation when used in conjunction with a colour-temperature meter (an

instrument that measures the colour quality of light in an interior, relative to the film-type being used, and calculates any filtration necessary).

Colour compensation tables (see Chapter 7, Table 7.1) refer to appropriate colour compensation in terms of a numerical density or strength, followed by the initial of the colour of the particular filter, or filters, required for the situation. They frequently also give the exposure increase in terms of *f*-stops necessary for the recommended filtration. For example, the filtration needed to compensate the colour of light from a 'daylight-fluorescent' lamp for reproduction on a daylight-balanced film is recorded as 'CC 40 M + 40 Y, 1 stop'. This means that filtration with a strength of 40 Magenta plus 40 Yellow is required over the camera lens, with an overall increase in exposure of one stop.

These filters are especially useful to compensate for colour casts created by discharge lighting, i.e. non-incandescent light sources such a fluorescent, mercury vapour and metal halide lamps which create light by means of an electrical discharge vaporizing a metal. The light produced may cover only narrow bands of the spectrum. However, the fluorescent coating on the inside of the glass tube of a fluorescent light expands the spectrum of light produced, enabling this type of non-incandescent lighting to be fully corrected in most cases. Colour compensating filters are also useful for correcting colour balance due to reciprocity failure of the film.

Unfiltered fluorescent lighting appears green on daylight-balanced film. To correct this, a magenta filter (known to some manufacturers as 'minusgreen') is placed in front of the lens. If further supplementary flash lighting is needed and is left unfiltered it would appear magenta on film as it has to pass through the compensating filter on the camera lens. To overcome this, green coloured filters need to be placed in front of the flash units to convert their white light output to the equivalent colour balance of the fluorescent tube output. These can be purchased as large sheets of gelatin, cut to size, and then clipped to the flash unit.

Problems arise in situations of mixed lighting, when sometimes only a best possible compromise colour compensation can be achieved (see Chapter 7); and under sodium vapour lamps which are discharge lamps that emit light of such a narrow yellow waveband it renders them uncorrectable. While critical colour compensation in situations of fluorescent lighting requires the use of a specific combination of colour compensation filters for perfect results (see Table 7.1), there are readily available fluorescent compensating filters for either 'daylight-fluorescent' (FL-DAY) or 'white-fluorescent' (FL-W) which are adequate for most general uses, and when not in possession of a colour-temperature meter.

In summary, the basic colour correction filters (80 A and 85 B) are essential equipment for interior photographers, and others in the series can be useful. With regard to colour compensation filters, the basic standard fluorescent filters are essential, while the full set of compensation filters of different densities are only necessary for critical work, when using a colour-temperature meter (see section on 'Meters' in this chapter).

Filter mounts

Colour correction filters (and the standard fluorescent compensating filters) are available in two different forms: either they are circular in a fixed mount that screws into the front of the lens casing (such as those by B&W and Hoya); or they are square and slide into a filter holder to which one

attaches different sized adaptor rings that correspond to the different diameters of the lens barrel (Cokin being the best known make). Both are excellent, the first type being faster to use and the latter being both more flexible and cheaper. The square variety is the cheaper system because it is only necessary to buy one filter holder with the different sized adaptor rings to suit your lenses, and the same filter is good for all sizes. (If the diameters of the lens casings are of widely differing sizes, it may be necessary to buy two different sizes of filter holder to cope with this wide variation.) The other advantage of the filter holder is that it can also carry colour compensating filter mounts.

Lighting

Supplementary lighting is usually necessary for photographing most interiors, for reasons explained in Chapter 4. Photographic lighting can broadly be divided into two main categories: flash and tungsten. Flash is the best choice to simulate natural, white daylight in terms of colour temperature. Where daylight is dominant in an interior, flash is the perfect 'fill-in' light for the most natural appearance.

Tungsten light, on the other hand, is a redder, 'warmer' light source. While it can be used as a 'fill-in' light source in the rare situations of exclusively tungsten available light (and the image recorded on a tungsten-balanced film) it can also be filtered to approximate white light. However, its most effective use in interior photography is for dramatic sunshine-effect lighting. It can be filtered in varying degrees to achieve the required effect of harsh, yellow/orange sunshine at different times of day. The light from a winter sun in early morning and late afternoon is much redder than a summer sun at noon (which is considered to be white) and its angle lower, penetrating further into the room. This can also be suitably emulated by lowering the height of the light stand.

Flash

Flash is the most practical and useful form of photographic lighting for interior work. As already mentioned, it closely approximates photographic daylight, without any filtration, and since daylight is often the dominant light source in interiors, this creates a natural and unobtrusive supplementary light source when bounced off a white umbrella or white wall.

Flash lighting comes in various forms: from a simple on-camera flashgun, through integral mains units, to flash heads powered by a studio power pack. Since the interior photography that is the subject of this book is, by definition, location work, portability is clearly an important factor in the choice of flash lighting.

By and large, the output of a portable flashgun will be too low for that necessary for lighting interiors, especially since the flash is usually not used direct but reflected off a white surface. This immediately reduces the output actually reaching the subject. However, it is handy to carry a portable flashgun in your camera bag as it is small and can be used with a 'slave unit' (a flash-sensitive triggering device) to illuminate dark corners or spaces, while actually hidden within the picture area itself. The flashgun fires the instant it receives light from another flash source.

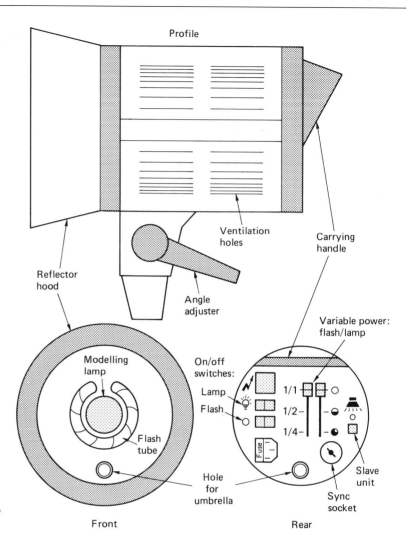

Profile

Ventilation holes

Carrying handle

Reflector hood

Angle adjuster

Variable power: flash/lamp

Modelling lamp

On/off switches:

Lamp

Flash

1/1

1/2

1/4

Fuse

Flash tube

Hole for umbrella

Sync socket

Slave unit

Figure 2.2 The integral flash unit: the profile, front view, and rear view showing the controls

Front

Rear

In terms of portability, a studio power pack with flash heads is impractical. The pack is large, heavy and unwieldy and necessitates extra, sometimes obtrusive, cabling. The most popular choice is a set of integral mains flash units which, although individually heavier as heads, are much more portable and simpler to use. The power of these heads ranges from the weakest at around 200 Joules to the most powerful (and accordingly the heaviest) at around 800 Joules. Heads with a variable power up to 500 Joules give a convenient output for lighting interiors. In many domestic and small-scale commercial interiors one or two heads are often sufficient, though it is sensible to carry at least three heads to enable you to cope with most situations.

The integral flash unit consists of a circular flash tube surrounding a modelling lamp (for previewing the effect of the light) at one end of the housing, with controls at the opposite end. The controls usually consist of a mains supply switch, two knobs for varying the output of the flash and

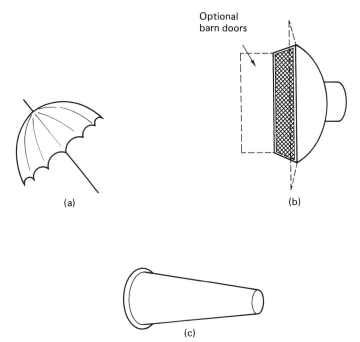

Optional
barn doors

(a) (b)

Figure 2.3 Various flash unit
attachments for different lighting
effects. An umbrella (a) for wide,
soft fill-in light; a diffuser (b) for
highlighting with a soft, square light;
and a snoot (c) for a harsh,
directional circular spot of light

(c)

modelling lamp, and a 'slave unit' – a flash-sensitive eye for triggering the unit when used in conjunction with one or more other units. Apart from having a synchronization cable from one of the units connected to the camera, every other unit only has to be connected to a regular 13 A socket. The flash-sensitive slave units trigger their firing as soon as the first unit is fired by the camera. This obviously happens at the speed of light, so there are no worries over the length of the exposure at shutter speeds slower than $\frac{1}{250}$ second.

When used for interior photography, the modelling lamps on the flash units give the photographer a rough idea of the quality and direction of light, and are useful to check visually for any unwanted reflections in the picture. They do not give a correct indication of the intensity of the flash output in relation to the available light. This can only be checked by exposure calculation followed by shooting an instant-print test shot.

All integral flash units have a hole through them from one end to the other which acts as a socket for attaching umbrella reflectors. Umbrellas are essential ancillary equipment, with black-backed white ones being the most useful for interior photography, and gold umbrellas occasionally for special effects – see Chapter 9. A variety of diffuser and snoot attachments are available which can be useful for highlighting specific areas in the image.

Finally, lightweight collapsable flash stands are necessary for mounting the flash units. These usually extend to a height of around 2.5 metres (8 feet) and collapse to fit into a tailor-made shoulder bag that should hold three stands and three umbrellas. The flash units themselves are best protected and most portable in the specially made cases available. These are commonly designed to hold two or three units.

Tungsten

Tungsten lighting plays a secondary role in interior photography, and as such is not essential equipment when starting in this field. It can, however, be useful for supplementary special effects lighting: for creating artificial sunshine on an otherwise cloudy and overcast day; or to simulate the effect of sunshine through a window when no such window actually exists. It has to be used cautiously and judiciously to be effective, or its artificial nature quickly becomes apparent.

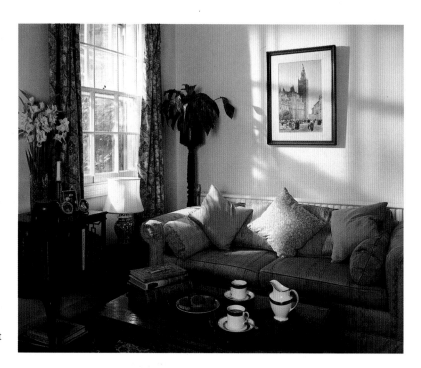

Figure 2.4 Creating the effect of sunshine on an overcast day. A 2000 W tungsten-halogen lamp was placed outside the window, with a half-blue colour correction gel placed in front of it. Because it was not a full correction, the light has a slight yellowish colour similar to that of sunlight

There is a variety of tungsten lamps available in many different housings. The cheaper, traditional short-life photofloods have given way to the more expensive, more powerful and more efficient tungsten-halogen lamps, available in wattages from 200–2000 W for general photographic purposes. The most portable variety for location work consist of a halogen lamp surrounded by a reflector. The position of the bulb is adjustable from 'spot' to 'flood', i.e. the deeper the bulb is seated in the reflector hood, the more concentrated the beam of light ('spot'); and the shallower the bulb is seated, the broader the spread of light ('flood'), see Figure 2.5. The beam of light can then be shaped with the adjustment of 'barn doors', four hinged shaders attached to the front of the reflector. These lights can be used either indoors as a window-shaped spot or from outside through a window as a sun-mimicking flood. A pair of such lamps, rated at around 1000 W, is a useful and effective complement to a set of flash units: desirable, if not essential.

A less portable, more weighty alternative to these relatively simple lamps is the focusing spot-lamp. This consists of a halogen bulb and a focusing lens in a long and heavy housing. The relative positions of bulb

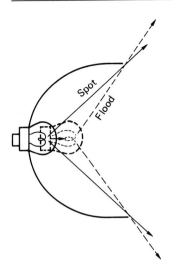

Figure 2.5 The tungsten-halogen lamp. The bulb position can be adjusted within the housing to create either a 'spot' or 'flood' effect. The deeper the bulb is seated in the reflector hood, the more concentrated the beam of light ('spot'); the shallower the bulb is seated, the broader the spread of light ('flood')

to reflector and lens to bulb can be adjusted to alter the beam diameter and control edge sharpness of the light spot. 'Gobos', or metal patterned inserts, can be added between the lamp and the lens with the effect similar to that of a projector. Light passes through the special effect gobo (available in various windows and foliage designs) in the same way a transparency is projected, with the image focused or blurred onto a wall/ floor to give the effect of sunshine through a window, or sunshine through a plant. Though effective in the truest sense of artificial lighting, focusing spots are probably better suited to studio work due to their artificiality, weight, and the weight of the stand needed to support one of these lamps.

Colour correction filters for tungsten

All tungsten lamps need a selection of colour correction filters to balance the colour temperature of their 'warm' light towards that of photographic daylight, depending on the degree of 'warmth' required from this artificial sunlight. It is rare to filter this effect completely to white as a degree of warmth gives the most natural appearance.

These filters come in the form of coloured plastic or gelatin sheeting which can be cut to any shape or size to fit over any lamp. Full Blue corrects tungsten (3200 K) to daylight (5500 K); also available are ½, ⅓, ¼, and ⅛ Blue for varying degrees of correction. Either a ½ Blue or a ½ + ¼ Blue make a good compromise between colour correction and a desired suggestion of warmth in the light.

Meters

There are three different types of meter that are used in interior photography: a light meter, a flash meter, and a colour-temperature meter. The first two are essential equipment, and the latter is optional, for critical precision work.

Light meters

A light meter is necessary for measuring the 'natural' available light in an interior before any supplementary photographic lighting is added. Since this is often treated as the dominant light source for the most natural appearance of a room, its correct measurement is of fundamental importance.

A hand-held meter can measure light in two ways. It can either record a direct reflected reading, which measures the quantity of light reflected off the subject (its brightness or luminance); or it can record an incident reading to measure the amount of light falling on the subject. Incident readings are more consistent as they are not affected by the reflectivities of the materials onto which the light is falling. However, whether reflected or incident readings are taken, an average brightness must be deduced from the whole of the subject area. While a spotmeter, which measures reflected light with a 1° angle of measurement, can determine the variations in light level across an interior, the centre-weighted metering system in a 35 mm SLR camera is useful for deducing a working average from several different readings across the picture area.

Whichever type of light meter is chosen, experience of it is the best way of achieving consistent results. If you are used to 'reading' the metering system of an old 35 mm SLR camera, then this is probably your best choice. If not, incident readings on a hand-held meter can be equally effective.

Flash meters

Flash meters are a specific type of light meter that are used to measure the strength of the very short, bright bursts of light emitted from a flash unit. They usually record only incident readings, measuring the intensity of the light reaching the subject and displaying the necessary aperture for average exposure at pre-set shutter and film speeds. While an essential piece of equipment, this does not need to be the best or most expensive on the market: the cheaper meters still measure the flash intensity accurately. With interior photography especially, the meter readings need only act as a guide since the flash is often the secondary light source to the dominant available light already in the room.

Colour-temperature meters

A colour-temperature meter measures the colour quality of light in an interior, relative to the film type being used. It records the colour temperature, any colour casts and calculates the filters needed to balance the colour of the available light to the particular film type in use.

Incident light readings are taken from within the picture area towards the camera. The light passes through a diffuser onto three separate silicon photocells, individually sensitive to blue, green and red light respectively. The relative responses of these photocells to this light is compared, displaying a read-out of any necessary filtration required.

It is an expensive piece of equipment and fortunately its use is not necessary for most everyday situations. Tables for colour correction and compensation (see Figure 2.1 in this chapter and Table 7.1 in Chapter 7) are readily available as guides to the filtration required for various different light sources. However, for precision interior work where perfect colour reproduction is critical this is the best tool for the job.

Figure 2.6 Colour-temperature meter. Light passes through the diffuser at the top onto three separate silicon photocells, individually sensitive to blue, green and red light respectively. The relative responses to this light of these photocells is compared, displaying a read-out of any necessary filtration required

Tripod

The importance of a robust, sturdy tripod cannot be overstated. Interior photography inevitably necessitates long exposures for which a heavy-duty professional tripod is essential. Both the changing of film backs and pulling out exposed sheets of instant-print film are substantial, jerky movements throughout which the camera must be held rock-steady to avoid even the slightest displacement from its critical position. Resetting a camera position if it has been displaced for any reason is a time-consuming and frustrating business, as it involves rechecking all the settings, including the focus.

Professional tripods are made up of two parts: the head and the set of legs, both of which are bought as separate items to suit the purpose for which they are required. A good head and a good set of legs are each likely to cost a similar amount, so allow for this when making your choice.

Though usually a little more expensive, it is best to buy a black tripod as this eliminates the problem of its reflection in glass or other reflective surfaces in the picture. Other than being sturdy and black, check that the legs (including the central column) extend to a height at least as high as your eye level and preferably somewhat higher for extra flexibility. Screw tighteners, rather than clips, for locking the legs in position are also a sensible choice as they avoid any possibility of a clip snapping off. The legs should have rubber feet to prevent the possibility of any instability from slipping or sliding on a smooth floor.

With regard to the head, it is essential for it to be heavy and to have plenty of available movement in the three dimensions, with large hand-sized handles with which to make necessary fine and tight adjustments. It is also useful to have the movement in each direction calibrated in degrees of angle: by zeroing everything, the operation of roughly setting up the camera in the first instance is speeded up; and if different critical angles of a view need to be taken this calibration makes it possible.

Finally, a quick-release head is another handy, time-saving device much to be recommended. It consists of a metal shoe which is screwed firmly into the base of the camera, and simply clicks in and out of the socket on the tripod head.

Necessary extras

As well as the actual photographic apparatus described in this chapter so far, there is one further bag of equipment that is extremely important to take on a shoot and should certainly not be overlooked. This is the bag of essential extras, including cable releases, flash-synchronization cables, extension cables, double/triple socket adaptors, Continental socket adaptors (if working abroad), and spare fuses for both the flash units and the plugs. A screwdriver with which to fit the fuses is required, and also spare modelling lamps, spare batteries for the meters and, if enough room, a roll of masking tape which has endless uses, including taping cables to the floor to prevent people tripping in a busy area. Finally, a small dustpan brush can prove invaluable for brushing in a consistent direction the pile of a dark carpet, or one with a sheen, in order to eliminate the distracting and unsightly footscuffs that such carpets attract.

3
Film and materials

Introduction

The quality of the film on which you shoot your image, and any photographic paper onto which those images are subsequently reproduced, is of as primary significance in the process of image recording as the optical perfection of the lens is for image creation. Perfect processing of film is also of fundamental importance, though it is something easily taken for granted with the reliable efficiency of modern commercial laboratories. Certainly with colour films, the speed and service of a commercial laboratory makes the need for in-house processing largely redundant, and avoids submitting your images to the sensitive, complicated process that it is without expensive automated machinery.

Black-and-white film processing, however, is both simpler and more tolerant of minor fluctuations in development temperature and time. With a light-tight changing bag and a development tank, films can be easily and speedily processed in-house if the photographer chooses, or handled with the same efficiency as colour films at a commercial laboratory if preferred. It is sensible for whoever is to print the images to do the processing as well, as he or she will know the most appropriate development time for the combination of enlarger and paper that is used.

Film

A golden rule with film choice is to keep it simple. Get to know, experience and understand just one or two films that will become your staple photographic diet for this kind of work. Not having to worry, or even think, about your choice of film is as important as being familiar with your camera. It enables you to concentrate fully on creating the picture without being distracted by the mechanics.

In most other branches of photography the photographer has to compromise film choice between one which has the finest grain but a very low film speed (which necessitates high light intensity for correct exposure) and a film with a high speed but larger grain for use in lower light level conditions. The advantage you gain in quality, you lose in terms of film speed.

When photographing interiors this compromise is not usually necessary as, by and large, the interiors are empty of any movement. Therefore long exposures can be used, with the camera on a tripod, to build up the necessary intensity of light. However, this can create its own set of

problems due to what is called 'reciprocity failure', i.e. the breakdown of the Law of Reciprocity. This law states that exposure remains constant whatever the chosen equivalent combination of exposure time and aperture. Unfortunately, film does not respond perfectly to low light-level conditions that warrant long exposures (or, for that matter, in conditions requiring extremely short ones). Extra exposure is necessary, and with colour films filtration also, due to a shift in colour balance. This shift comes about as the three layers of emulsion react differently during long exposures.

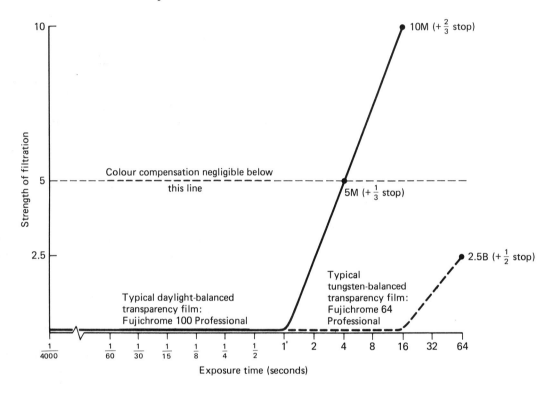

Figure 3.1 Reciprocity graph. This graph shows the recommended exposure duration for a typical ISO 100 daylight-balanced colour transparency film and for a ISO 64 tungsten-balanced film. Reciprocity failure requiring up to a strength of CC05 filtration is negligible. The graph demonstrates how tungsten-balanced film is designed for the longer exposures necessary for high-quality interior work

Storage

For the best possible results from your choice of film you should use film as fresh as possible to render a neutral colour balance when processed. As film ages, its overall colour balance shifts, it becomes less sensitive to light, and its contrast diminishes. With general-purpose amateur films, the manufacturer assumes that it will be an average of three months before the film will be used. It is therefore created to have a neutral colour balance after ageing for three months at room temperature. However, with 'Professional' films the colour balance is neutral at the time of production and therefore should be refrigerated till used to halt the ageing process. This means that when using a refrigerated 'Professional' film the photographer can be confident that the overall colour balance of the film will be as neutral as possible.

In case of any minor factory variations of colour balance it is best to shoot each assignment with film that has the same batch number (shown on

the side of the box along with the expiry date) in order to achieve consistent results. This is most easily done by buying film in relative bulk.

This book is primarily concerned with colour photography, and since 95% of all interior photographic assignments require colour transparencies as the end product, I shall restrict detail on both colour and black-and-white negative materials.

Colour transparency film

Colour transparency film is the popular choice of most commercial photographers, and is widely used for the purpose of mechanical reproduction. It gives an original image, as opposed to a print from a negative which is necessarily once removed from the original. Also, due to its transmission of light, it has much higher luminance in the lighter areas than the whitest of white base paper of a photographic print could ever achieve. Since the final published image is twice further removed from the original supplied by the photographer, it is essential to give the publisher an original of the highest possible quality from which to work.

Having concluded that a high-quality, fine-grain colour transparency film is the best for interior work, there are further choices still to be made. Colour transparency films are available in two varieties: daylight-balanced and tungsten-balanced. Both are useful for interiors, but for reasons different to those that their descriptions suggest.

A slow/medium-speed film for general-purpose interior work would be a professional daylight-balanced film rated at ISO 100 – for example, a Fuji Fujichrome of Kodak Ektachrome transparency material. This type of film is extremely versatile and of very high quality. It requires no filtration when daylight through windows combined with flash is the primary light source, and it suffers no reciprocity failure as long as exposures are no longer than a couple of seconds. It is the ideal film choice when time is an important factor, when you have to get good images without spending half a day over each shot (see Chapter 5). The precise film choice you make is a personal decision to be arrived at by direct comparison of the same subject on several similar films by different manufacturers.

The specialist film for interior work is a slow, tungsten-balanced (Type B) film rated at ISO 64, not so much for its tungsten balance (though this can be useful when tungsten light is the only, or very dominant, light available in a large interior) but because it has been specifically designed for long exposures. There is no significant reciprocity failure between $\frac{1}{15}$ second and 30 seconds, with minimal failure up to one or two minutes. For most interior work where daylight is the dominant light source an 85B colour correction filter is necessary over the camera lens, and this has the effect of reducing the effective film speed by one stop to ISO 32. With such a slow film speed, long exposures become essential. The long exposure time also enables the flash to be fired several times, if this is necessary, to build up sufficient flash intensity. Again, the major manufacturers all produce their own versions and I would recommend a direct comparison experiment as the best way to make your preferred individual choice.

All daylight-balanced and tungsten-balanced transparency films use the Kodak E-6 process for development (other than Kodachrome films, which have to be processed almost exclusively by Kodak themselves).This is an eleven-stage, one-hour process (inclusive of drying time), with a usual turnaround time of 2–3 hours in a professional laboratory.

Colour negative film

Although excellent colour prints can usefully be produced either directly, positive to positive, from a colour transparency, or indirectly via an internegative stage, colour negative film is still the most popular option when colour prints are the only desired end product of a shoot. The quality is obviously better than going via an extra internegative stage, and cheaper for long print runs than direct positive to positive prints from a transparency. The image quality is also quite different, and therefore choice of printing from negative or transparency is dependent both on requirements and personal preference.

A slow/medium-speed film would be appropriate for interior work for reasons described in the section on 'Film', though for very long exposures it is still susceptible to reciprocity failure. Colour balance on negative film is not as critical as that on transparency film, as minor colour variations at the time of exposure can be filtered out at the printing stage to produce the desired colour balance.

Since negative film alone cannot, by definition, produce a positive image for viewing, the quality of the final image is as dependent on the paper on which it is printed as the film on which it was taken. For these reasons, experimentation under the same conditions is the best route for discovering your personal choice of film/paper combination, concentrating on the comparison of tone, detail sharpness, grain size, and the richness and accuracy of the colour rendition.

Figure 3.2 The different routes available from film to colour print

Colour negative films are developed using the Kodak C-41 process. This is a seven-stage process that takes approximately 45 minutes (inclusive of drying time), with a turnaround time of anything from one hour in a professional laboratory.

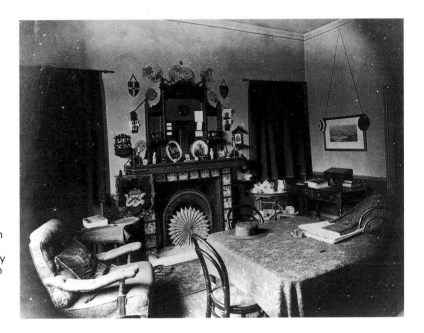

Figure 3.3 Black-and-white film is the ideal medium for the archival recordings of buildings. It is more consistent for the direct comparison of shots, as it avoids the distraction of varying colour balances in partially faded colour prints. This photograph was taken of a student's room at Trinity College, Cambridge in the 1880s, by William Dunn (great-grandfather of the author)

Black-and-white film

The major use for black-and-white film in the realm of interior photography is for the archival recording of buildings. This is the preferred film type of the National Monuments Record, for example. Black-and-white films have proved their durability over a long period of time if stored correctly, and are not prone to the potential fading of synthetic dyes in colour films. Furthermore, photographic archives on black-and-white film and paper are more consistent for the direct comparison of shots taken at different times than a variety of different colour films with slightly different colour balances and varying degrees of fading. That in itself could be an unnecessary distraction.

By comparison with colour film, and transparency film in particular, black-and-white negative film with its single layer of emulsion is both forgiving and simple to use. It is tolerant of minor exposure variations, and obviously avoids any problems caused by unwanted colour-casts from artificial light sources and those created by mixed lighting conditions. It is also flexible in the way it can be processed and printed, enabling a wide range of possibilities for the final print in terms of grain, contrast and sharpness.

Again, a slow/medium-speed emulsion is recommended for everyday use, typically ISO 100 to ISO 125. However, for precision work with the finest detail, the sharpest film with the smallest grain is a slow film with a typical speed rating of ISO 25 or ISO 32, used in conjunction with a fine-grain developer. These slower films have slightly higher contrast than the

medium-speed emulsions, though this can easily be reduced at the printing stage.

Extra photographic lighting is usually necessary when photographing interiors to reduce the contrast of the natural daylight to a level that can be fully recorded on film. While this is often essential for colour film, and preferable with black-and-white film, contrast on the latter can be controlled to a degree by overexposing the film in the camera and correspondingly reducing the development time. Contrast can be further reduced or boosted at the printing stage depending on the contrast balance of the printing paper you choose. If complicated exposure/development variations are likely to be a regular part of your interior work then you would probably be best off processing and printing your own films, as your experience will be the best guide to achieving perfect results.

Instant-print film

The importance of instant-print film, available in both colour and black-and-white, cannot be overstated. When used in an instant-print magazine back that has been interchanged with the regular film back on the camera, it can produce a positive image of the precise image you are intending to take in only 90 seconds after exposure. It enables you to check for correct lighting, exposure and any unwanted flash reflections, which gives you unprecedented confidence that what you believe you are recording on film you will successfully be recording when you change film backs.

There are several types of instant-print film available which the manufacturers have at last matched to the film speeds of the popular film types. Polaroid Polacolor Pro 100 film is a daylight-balanced colour film rated at ISO 100 – ideal when used in conjunction with ISO 100 daylight-balanced transparency film. This produces a positive image 90 seconds after exposure at temperatures between 21°C and 35°C. Processing time is increased to 120 seconds at 16°C.

Similarly, Fuji FP-100C film is also a daylight-balanced colour film rated at ISO 100, varying the process time with the ambient temperature from 180 seconds at 15°C to 60 seconds at 35°C.

When working with ISO 64 tungsten-balanced film, the perfectly matched instant-print film is Polaroid Polacolor 64 Tungsten film. With this film, film speed is nominally kept constant along with processing times, but exposure adjustments of a third of a stop must be made according to the ambient temperature.

Matching the instant-print film to the transparency film to be used overcomes the need to make complicated exposure calculations between films of different speeds and colour balances, and therefore makes a lot of sense but is not obligatory. Precise processing times or exposure adjustments are clearly detailed on each pack.

The instant-print magazine back on a camera often produces a larger image area than the transparency film size allows. Therefore it is important to carry a transparency-sized mask, preferably the type used for eventually mounting the transparency, as this will show you the precise image area that will be recorded on film. Any extraneous objects, cables, reflections, or flash units outside of this area on the instant-print are obviously not worth worrying about. The advantage of having the larger image area on the instant-print is that it enables you to shift the mask around to check that composition for the film area is perfect. Sometimes at this stage, by using

Figure 3.4 The instant-print magazine back attached to a medium-format SLR camera. It produces a positive image only 90 seconds after exposure, enabling you to check for unwanted flash reflections, lighting, and exposure before shooting the final transparency or negative film

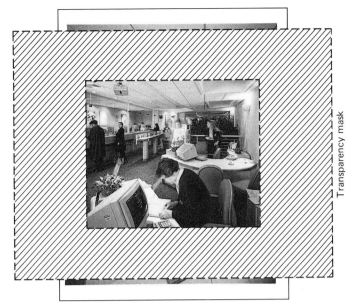

Transparency mask

Instant-print

Figure 3.5 The instant-print magazine back often produces a larger image area than the transparency or negative film size allows. A transparency-sized mask enables you to crop the image to the size of the final transparency, for viewing. You can also move the mask around the instant-print image to check your composition

this technique you can clearly see that by shifting the mask up and increasing the ceiling area makes a more dramatic shot, or by shifting the mask down and including more of the floor favourably expands the apparent size of the floor area relative to the height of the ceiling. If this is the case, corresponding lens shifts can easily be made on a viewcamera by shifting the front or rear standard up or down, without affecting the focus.

Leaving for the shoot

It is important to thoroughly check through your equipment before setting off for the shoot, as it is all too easy to leave behind a vital piece of equipment (or even the film!) which can prove both tedious and costly. The best way to do this is to check logically through the procedure: tripod, camera, film (including instant-print), flash units, stands, umbrellas and other flash attachments, plus all accessories including meters and spare batteries and bulbs. If possible, have each grouping of equipment in its own case, so that each case can be checked off in the knowledge that it is complete within. This also helps when packing up after the job – if every item has its own place within a specific case, a quick visual check can reassure you that you have not left anything behind.

4
Approach

Introduction

On arriving for an interior shoot, the first thing to do is to get a feel for the room or rooms to be photographed, and to make a mental note of the direction that the windows in each room face in order to calculate a shooting sequence that will make the best possible use of any available natural sunlight. A compass is a useful aid, bearing in mind that the sun

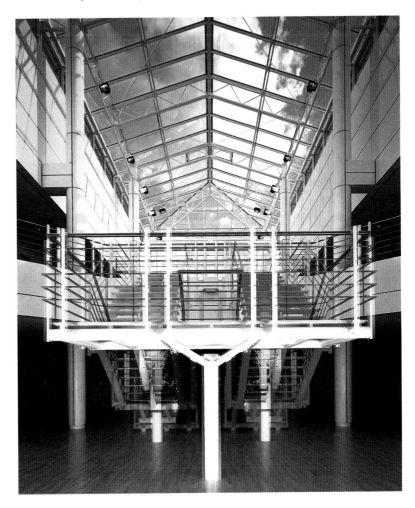

Figure 4.1 The basic symmetry of the atrium and staircase of the Nissan European Technology Centre, Milton Keynes is most effectively photographed using a symmetrical composition. The asymmetry of the staircase adds enough interest to break up the sterility of complete symmetry. Notice also how the dominant half-landing on the staircase and the apex of the atrium lie approximately on the horizontal thirds of the picture

rises in the east and sets in the west, traveling in a southerly arc (the precise angle of which varies with the time of year).

Having selected the interior in which you have chosen to start, find a position from which the camera can see the most significant elements of it, in a configuration that is likely to best convey the aesthetic concept of that interior. Often this position is in or near a corner of the room showing windows, at least two walls, and as much of the spatial qualities of the interior as possible.

Composition

Two basic approaches dominate picture composition in photography: the symmetrical and the Law of Thirds. Whether we like it or not, most photographs fall within one of these two categories to a large degree.

Symmetry

Exactly as it suggests, the symmetrical picture is constructed to show the perfection of the symmetry of the subject. For example, the most exciting and aesthetically pleasing way of photographing either a grand Georgian entrance hall or a modern commercial atrium of perfect symmetrical proportions might well be from the precise central point as you enter the door. This would give the effect of showing the interior exactly as the architect would have intended, in all its symmetrical perfectionism, while creating a visually stunning shot in itself. However, symmetrical composition should only be used for exceptional interiors that truly demand such treatment. Unless appropriately chosen and skilfully executed, there is a tendency for symmetrical composition to appear dull and unimaginative. A flash of asymmetry within an otherwise perfectly symmetrical shot can often add that extra spark of interest.

The Law of Thirds

The Law of Thirds approach, whether consciously or unconsciously, dominates the majority of all photographs, not just those of interiors. The Law of Thirds is an aesthetic truth: an approach to composition that universally appeals to our sense of beauty.

First, imagine your picture area, as in Figure 4.2. Intersect that area along the thirds, in both directions. The basic rules of the Law of Thirds are as follows:

(a) The main subject(s) should be positioned on or near an intersection of the thirds.
(b) Some other element of the picture should lead the eye towards the main subject.
(c) The main subject should contrast with the background, either in tone or colour.

Spend a while considering the implications of this, as it is probably the most fundamental law of picture composition.

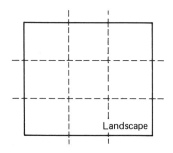

Figure 4.2 The picture area, intersected along the thirds. The Law of Thirds applies to both 'portrait' and 'landscape' picture composition

Figure 4.3 The interior photograph of a typical living room has been intersected according to the Law of Thirds. Notice how the main focal points – the light, the mirror, the fire grate, and the bowl on the table – all lie more or less on the intersections of the thirds. The angle of the table leads the eye towards the warmth of the hearth, and the furniture contrasts well with the pale walls.

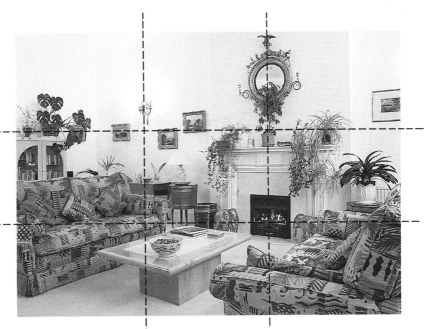

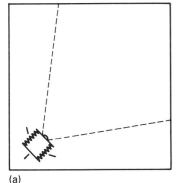

(a)

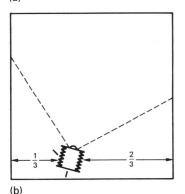

(b)

Figure 4.4 The different camera positions needed, depending on whether (a) two or (b) three walls are to be included in the photograph. In diagram (b), the camera has been shifted a third of the way along the length of the back wall to avoid photographing the extra side wall at too oblique an angle

Spatial values

When photographing an interior, the photographer usually wants to suggest the spatial value of the room as one element of the composition. To do this it is necessary to include more than one wall (either two or three) to give the viewer the illusion of depth. In order to include two walls and show maximum floor area, the best camera position is usually in one corner looking towards the opposite corner. If three walls are to be included, the best place is often a third of the way along the length of the back wall, as shown in Figure 4.4, to avoid photographing the extra side wall at too oblique an angle. Junctions of walls, floors and ceilings can be at the intersection of the thirds in the photograph (though not in the case of Figure 4.3), as with interior photography the flow of these lines can be as important an element as any foreground furniture.

Once the composition of the spatial area is basically established, the foreground composition has to be set, often with the dominant piece of furniture or decoration standing at the intersection of the thirds on the bottom horizontal. Further depth to the picture can be created by the addition of a piece of furniture in the immediate foreground, as with the sofa in our example, cutting across the bottom-right corner of the frame. It also adds interest to the composition.

Figure 4.5 'Diagonals introduce powerful directional impulses, a dynamism which is the outcome of unresolved tendencies towards vertical and horizontal which are held in balanced suspension' (Maurice de Sausmarez)

Dynamics of composition

When composing a photograph there can be a tendency to try to fully contain the whole of the subjects you have chosen to include in your picture. It is important to be aware of this and to remember that actually the borders around the image exist as much to be broken as to contain the essential elements. The image is most exciting when the borders are broken at oblique angles, both by pieces of furniture and by the lines created within the composition of the picture. The basic human significance of such visual dynamics is most eloquently described by Maurice de Sausmarez in his book *Basic Design: The Dynamics of Visual Form* (The Herbert Press, 1983):

> Horizontals and verticals operating together introduce the principle of balanced oppositions of tensions. The vertical expresses a force which is of primary significance – gravitational pull; the horizontal again contributes a primary sensation – a supporting flatness. The two together produce a deeply satisfying resolved feeling, perhaps because together they symbolize the human experience of absolute balance, of standing erect on level ground.
>
> Diagonals introduce powerful directional impulses, a dynamism which is the outcome of the unresolved tendencies towards vertical and horizontal which are held in balanced suspension.

Individual interpretation

The example interior, in Figures 4.3 and 4.6, obeys all the rules of composition and has some lively lines cutting the borders at suitably oblique angles. This is perfect within itself, if perhaps a little dull for its

Figure 4.6 The living-room photograph has been taken from an angle that maximizes the dynamic lines within the composition. The impact of an image is enhanced when its borders are broken at oblique angles by the lines

perfect obedience. We can go one step further with this image by breaking or exaggerating the rules to create our own individual interpretation of the interior. At this point, one's personal aesthetic parts company with the technical rulebook to create that individual interpretation. Its origins, however, are still firmly rooted within the boundaries of the basic principles of composition.

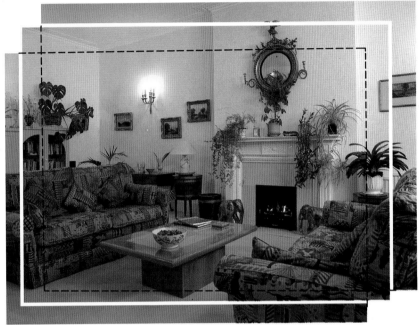

(b)

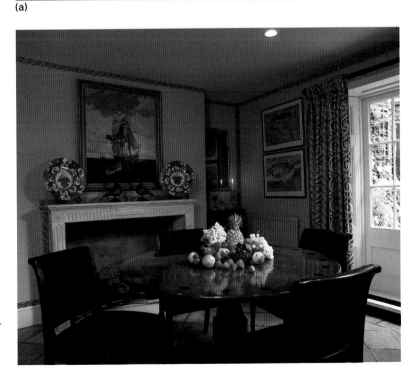

(a)

Figure 4.7 Shifting the frame position either up or down can exaggerate the perspective in a photograph, and therefore alter the apparent atmosphere of an interior. Image (a) creates the illusion of an expanded floor space with a high ceiling; while image (b) suggests a foreshortened floor space with a low, oppressive ceiling

Figure 4.8 The freshness and colour of the fruit on the dining-room table gives the picture a rich, added vitality

Frame positioning

Returning to our original composition, we can see in Figure 4.7 the different ways in which the frame positioning can exaggerate perspective in the image. In image (a), perspective has been enhanced by lowering the area of lens coverage to take in more floor and less ceiling. This creates the illusion of an expanded, more inviting floor-space with a high ceiling, especially when using a wide-angle lens. In image (b) however, the reverse is true. Raising the area of lens coverage creates an apparently foreshortened floor space with a low, heavy ceiling giving an oppressive feeling to the interior.

So through even just simple shifts in lens coverage, the atmosphere of an interior can change its character. Clients often prefer to see a little more of the floor space than the ceiling, especially in the commercial property market, where an exaggerated sense of floor space is always appreciated.

Styling

Having selected the optimum camera position and established the basic composition for the photograph, it is time to turn your attention to the detail of the interior, and to style it if necessary to enhance its character, aesthetic appeal and interest. This is especially important for residential and office interiors, which are usually massed with small details.

Styling is often a question of rearranging objects already in the room into a more aesthetic arrangement from the point of view of the camera angle and the composition. By styling mainly with objects already in the room, harmonization of these objects within the established aesthetic concept of the room is virtually guaranteed.

Different interiors demand different treatment: a rambling and cluttered country cottage interior will require a more casual approach than a formal stately home, where detailing will often need to be precise, neat and tidy. The photographer, or stylist if one is employed, has to make a judgement of the atmosphere and character concept of the interior, and then exploit it to its best advantage.

One styling addition that can dramatically enhance the appearance of residential interiors is the introduction of appropriate flowers or fruit, as illustrated in Figure 4.8. They add freshness and colour to the picture that give the photograph added vitality. Again, it would be appropriate to have wild flowers in an old jug in a cottage kitchen but exotic lilies or perfect roses in a fine cut-glass vase in a stately home.

Detailing

Unless specifically designed to be minimal or very formal, interiors are usually more interesting with plenty of detailing. A bare wooden table is never as interesting as a table laid for a sumptuous meal, or a sideboard covered with unusual trinkets and books which serve to fuel our understanding of the interior and the lifestyle of the people who have created it as their living space.

The detailing should also tell a convincing story both to make the interior more inviting and, again, to increase our understanding of it. It

should draw us in, invite us for a meal or cup of coffee, and make us feel comfortable and 'at home' once we get there.

In a dining room or kitchen, have the table laid for a meal or succulent food mid-preparation, or have a few tastefully arranged remains of a meal with a chair pulled out from the table and angled towards the viewer, as in Figure 4.9. Avoid unsightly packaging and brand names: go for the wholesome approach. In the living room or study, have a few books or magazines casually arranged on the coffee table, chair or desk, and leave one open under a lamp with an open pair of glasses on it to suggest that someone has just left their chair briefly. In a bedroom, leave a dressing-gown casually strewn (yet carefully arranged) across a corner of the bed; and in the bathroom, throw a towel over the edge of the bath. In an office interior, have the corner of a financial paper draping down the side of a desk, and business papers in a none too tidy pile. Maybe an open fountain pen on a half-written pad of paper.

These are just suggestions to try to create a feeling for the approach to styling. Involve yourself with the room and work within it, as part of it, and then an understanding of appropriate styling should make itself clear.

Only a fine line exists between being bold and highly individual with your styling of interiors and being inappropriately outrageous to the point of ridicule. True creativity is knowing how to ride this delicate line between unacceptability on the one side and unoriginal mediocrity on the other.

As with composition, it is the point at which you start to break or stretch the rules that can produce the most creative styling. And again, this is where individual interpretation has its freedom of expression, which is why no two photographers will ever take exactly the same interior photograph of the same room.

Lighting

All interiors have their own individual combination of 'available' light sources, by which the naked eye views them. This is often a mixture of daylight through the windows, with some form of artificial lighting to supplement it: a ceiling light or table lamps, for example. This available light, especially the daylight, creates mood and atmosphere in the room, and it is this that we want to convey on film.

However, the contrast between the light and shade areas in an interior, though readily discernible to the eye, is usually too great to record on film: the light areas tend to 'burn out', and the shadow areas become a black void. The reason for this is that while the eye is sensitive to a range of at least 10 stops, colour transparency film only records about a five-stop range and colour negative film a seven-stop range.

In order to reduce the contrast, and thereby enable us to record the image clearly on film, we have to supplement the existing light with photographic lighting. This is a very subtle process, as we want to preserve the atmosphere and interplay of light and shade in the room, while reducing the contrast to acceptable photographic levels.

'Fill-in' lighting

In order to do this, lighting added by the photographer must be of a 'fill-in' nature, allowing the available light to remain the dominant source of

illumination, except where special effects are required. This fill-in light, due to its secondary though important role, should be a diffuse light source, typically a flash bounced off a white umbrella or white wall. Such diffuse lighting is the most subtle way of inconspicuously reducing the contrast of the available light.

Figure 4.9 The detailing of an interior should tell a convincing story. Here the kitchen table is laid to suggest a lazy morning with coffee and newspapers

Placement of lights

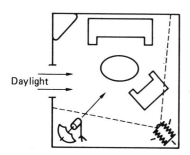

Daylight

Figure 4.10 The placement of photographic lights for the fill-in effect. The best place is at an angle between the camera and the dominant light source (often a window). This maintains the gradual transition from light to shade, while subtly reducing the contrast to recordable levels

The precise angle of this fill-in light is not critical due to its diffuse nature. However, placed at an angle between the camera and the dominant light source (often a window), the gradual transition from light to shade is maintained, but the contrast subtly reduced. An angle closer to the camera, or even on the opposite side of the camera to the dominant light source, is usually acceptable, though tends to diminish the effect of atmospheric transition from light to shade. A fill-in light on the opposite side of the camera also runs the risk of creating its own conflicting set of shadows, thereby reducing its subtlety. A well-lit interior should give the viewer the impression that no extra photographic lighting has been used at all.

Strength of 'fill-in'

The strength of this fill-in light should be approximately one-quarter the power of the dominant light source. In other words, the reading taken off the furniture or floor of the strength of the available light should be two stops greater than the flash reading at a similar place.

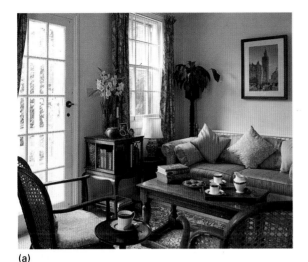

(a)

(b)

Figure 4.11 (Above) Fill-in lighting. In photograph (a), the interior appears as the eye sees it. Because the sensitivity of the eye is much greater than the sensitivity of the film, subtle fill-in flash lighting has been added to reduce the contrast to recordable levels. Photograph (b) was taken without supplementary photographic lighting. The contrast is high, with the windows burning out and the shadows deep, losing the detail.

Figure 4.12 (Below) Great care must be taken to ensure a natural continuity between two or more different shots of the same interior. The same lighting ratios, exposure and styling must be preserved throughout. Such continuity is displayed in this general and detail shot of a cottage kitchen

Different requirements for different clients

The precise approach that a photographer adopts to shoot a particular interior assignment will depend first, on the use for which the photographs are being taken, and second, on the dictates of the client's preferred style. For example, a property agent is likely to expect bright, clear, evenly lit images, with perhaps stronger than usual fill-in lighting. He or she will probably prefer you to shoot with your widest available lens (without linear distortion) to maximize the illusion of space in the room, and to include as many windows in view as possible to create the impression of a property with plenty of natural daylight. An architect, on the other hand, is more likely to be interested in symbolic shots showing the aesthetic and functional style of a particular building and its interior. While a wide shot will inevitably be part of the brief, the wide-angle lens is used more to exaggerate a specific aspect of the interior than to emphasize floor-space.

Editorial clients also have different preferences. For example, while they like to emphasize the atmosphere of the interior, created by available light, they differ in opinion over whether room lights should be left on or off. One major interior magazine believes that room lights and lamps should never be switched on. The philosophy behind this is that one only turns on the lights on grey or rainy days, and that this magazine is not in the business of selling such dull days to their readers. Consequently, they also aim to shoot most of their features in the summer months. Another magazine, on the other hand, which specializes mostly in interior-designed rooms, likes to have the lamps switched on in order to best show off the lampshade designs. Some magazines prefer the use of a standard lens where possible rather than a wide-angle, in order to create a more intimate and natural perspective, similar to the eye-view of an interior.

A knowledge of the preferences and priorities of your clients is, therefore, essential. When starting work with new clients, it is always worth inspecting their past publications to gain the best possible understanding of the way they like to work.

Detail shots and continuity

Alongside general interior shots, a client is likely to demand detail photographs as close-up extras to boost the illustrative impact of a set of pictures. These can range from decorative detail shots for a magazine feature of elaborate pieces of furniture, as styled for the main shots, to detail shots of cornicing or door handles to enhance the feel of quality in a property brochure. Modern light fittings or abstract construction detail may be the demand of an architect. Such details are important extra shots and should always be considered when working out your overall shooting sequence. Furthermore, it is sensible to decide at this stage which images are to be shot landscape, and which portrait. A mix of each will give the editor and designer a wider scope for layout, and will enhance the visual interest of the printed page.

When several shots are taken of the same interior from different angles, including detail photographs, great care must be taken to ensure a natural continuity between them, of both lighting and styling (see Figure 4.12). The same lighting ratios between available light and flash must be maintained throughout to retain the same all-important atmosphere in the

room. It is essential not to have the same lamp in two different shots showing a different brightness on film.

It also helps in a set of photographs of an interior to show continuity between the shots in terms of furniture in view. In other words, it is best if possible to have one or two pieces of furniture or obvious features that appear in all the shots, from different angles and perspectives, to act as mental reference points for the viewer.

5

Technique Part 1: The practical everyday method

Introduction

This and the following chapter are about the actual mechanics of taking the photograph in order to achieve the best record of the image on film. They will outline two alternative methods: in this chapter a simpler, faster alternative; in the next a more complicated but thorough method for creating a recorded image of the highest possible standard. Both methods are valid in the realm of professional photography as pressure time can often necessitate the use of the simpler 'practical everyday method' outlined in this chapter. After all, it is obviously better to get good shots reasonably quickly than not at all. Depending on the usage, it is often prohibitively costly to the client to strive for complete perfection and also quite unnecessary. For example, an estate agent would be unhappy to pay a photographer to spend half a day shooting one interior; whereas in the world of advertising, or for the purposes of a specialist brochure or book, that would be both much more acceptable, and most probably expected.

Figure 5.1 Geometric distortion: the closer an object is to a wide-angle lens, and the further it is from the central optical axis of that lens, the greater the geometric distortion of that object. Consequently, the plates in the foreground of this picture appear as ovals sliding out of the composition. This effect has been further exaggerated by the use of shift movements

Lens selection

Having chosen the best position from which to take the photograph, select the appropriate lens for the job. This is likely to be a wide-angle lens, often the widest angle available due to the usual restrictions of space (not being able to get back far enough). It also gives the best depth of field, and maximizes the illusion of space in a room by exaggerating the perspective.

This exaggeration of perspective must, however, be used judiciously, as in photographic terms it is a form of distortion. The closer an object is to a wide-angle lens, and the further it is from the central optical axis of that lens, the greater the visual distortion and unnatural appearance of that object. For example, round plates in a bottom corner of the frame, photographed on a foreground table, can become awkward ovals sliding out of the composition, as in Figure 5.1. This can be further exaggerated by excessive shift movements, as any shift movement is a shift away from the central optical axis of the lens.

All wide-angle interior photography, therefore, is a compromise between coverage and distortion, though the effect of this distortion can be gainfully employed if the maximum illusion of space is demanded and due care is taken. Otherwise, a rule of thumb for lens selection is to select the longest focal length lens capable of including all the significant elements of the interior. If it is a feature or small part of the interior that you wish to photograph, a standard lens may be more appropriate as it has approximately the same focal length as the human eye, thereby giving the perspective in the image a high degree of normality.

Mount the camera on the tripod in the perfect position and get it roughly focused so that you have a clear idea of the picture you intend to take. Check with a spirit-level that the film plane is perfectly vertical to avoid any converging or diverging of the verticals in the image. If you need to include more of the floor or ceiling in the picture while retaining perfect verticals, you can do one of two things. You can either lower or raise the height of the camera on the tripod or, if using a viewcamera, you can raise or lower the front or back standard, which has the added advantage of also maintaining the level of the viewpoint already selected.

Lighting

Next, consider the lighting in terms of what is available, how you choose to supplement it, and the effect you wish to create. Assuming you decide that the daylight through the windows is to be the dominant light source, you then have to consider whether or not you want any of the artificial room lights or table lamps switched on. These can add warmth to the picture and can brighten otherwise dimly lit corners, but they can also diminish the subtle atmosphere of an interior that appears to be lit only by daylight. Different combinations are appropriate for different purposes, as discussed at the end of the previous chapter, and again it comes down to both personal preference and specific use of the photographs.

Having made your decision, you must next set up one or more flash units (depending on the size of the interior) to act as the fill-in light to reduce the overall contrast in the photograph. If you are cramped in a corner, set up the flash unit beside the camera. Bounce the light off a white umbrella if space allows, or alternatively, off the top apex of the wall behind you if the

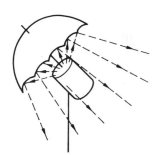

Figure 5.2 The effect of flash bounced off a white umbrella is similar to that bounced off the apex of a white wall and ceiling. This is a useful way to light an interior when space is restricted, and it also avoids the problem of unsightly umbrella reflections

wall is white (any other colour will create a colour-cast in the fill-in). Keep the height of the flash unit above that of the camera so that the fill-in flash bounces slightly downwards onto the scene, at a similar angle to daylight through a window. Try to avoid placing the flash unit too close to any individual piece of furniture. This will allow the fill-in to penetrate as far into the room as possible, without 'burning out' any piece of furniture in the foreground.

If you are not cramped in a corner, fill-in flash is at its most subtle when bounced in from the side, at a place between the camera and the window, thereby supplementing the direction of the daylight from the window and maintaining the gradual transition from light to shade, while reducing the contrast to recordable levels.

With the flash unit(s) in place, make any necessary styling adjustments and check the image in the viewfinder. Look out for unwanted flash reflections and adjust the position of the flash units, camera, or both as required.

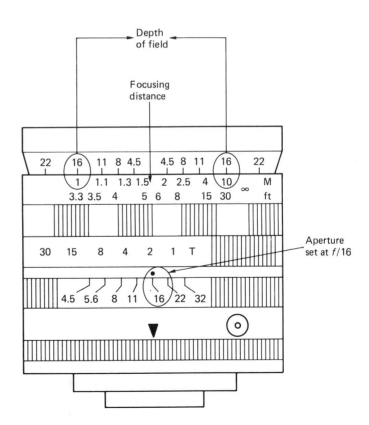

Figure 5.3 The depth of field scale on a roll film SLR camera lens. The aperture markings show the limits to the depth of field for any particular aperture when compared with the distance markings. In this example, on a 50 mm medium-format wide-angle lens at f/16, the image would be sharp between 1 and 10 m when focused at 1.7 m

Focusing

Next turn your attention to final focusing. To ensure absolutely perfect focus throughout the image area, one has to calculate the optimum plane of focus and necessary aperture for the required depth of the field, but this is something we will come to in the next section on the 'critical precision method'. More simply, for the purposes of this quicker alternative, most SLR roll film camera lenses have depth of field scales engraved on them which give a reasonably accurate guide as to the available depth of focus for any particular aperture (see Figure 5.3). A simple rule-of-thumb technique (so long as your aperture will be a minimum of two to three stops smaller than its widest) is to focus at a point halfway between the mid-foreground and the far wall. This should guarantee that the far wall is in focus and gives you a good chance that close foreground objects will be in focus also. Check it visually by looking through the viewfinder with the lens stopped down, though this is sometimes difficult due to low levels of available light. If there is any doubt, it is usually better to ensure that the background is in focus rather than the foreground, as this tends to be more visually acceptable.

Film

The film I recommend for this 'practical everyday method' is ISO 100 daylight-balanced colour transparency, as this requires no filtration where daylight is dominant and the fill-in is from a flash source. It does not suffer any significant reciprocity failure at shutter speeds up to a couple of seconds.

Flash/light metering

One or two 500 J flash units are adequate as a fill-in for most residential interiors when using this speed of film, though for large interiors more units will be necessary. The simple, though unorthodox, part of this method is to allow the maximum output of the bounced flash to dictate the aperture setting on the camera. This avoids the complicated calculations of depth of field, focus, and flash build-up necessary for the 'critical precision method'.

So take an incident flash reading from a point approximately a third of the distance between the flash and the farthest wall, or off the first piece of furniture in the picture that is in its line of fire if that is closer. Assuming a typical reading of, for example, $f/11$ at ISO 100 from the flash output, you use this as your working guide. Next turn off the modelling lamps on the flash units. Then, using your light meter, take several exposure readings for an $f/11$ aperture setting. Take these as either direct readings off the floor, walls and furniture (or off a grey-card) around the middle of the room; or as incident readings from similar places. Avoid directing the meter at the windows as their intense brightness will cause misleading readings. Determine a mean, compromise exposure for the general available light level in the room. This could, for example, be ¼ second at our predetermined $f/11$ aperture.

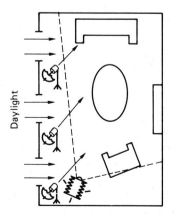

Figure 5.4 The placement of photographic lights in a large interior for effective fill-in lighting

Evaluation of lighting ratio variants

A ¼ second exposure at *f*/11 would give us an even balance of flash and available light, thereby creating a flat and uninteresting, uniformly lit image. To increase the effect of the daylight at the expense of the flash in order to create a more interesting, atmospheric and natural look in the image, it is necessary to increase the exposure time and correspondingly reduce the size of the aperture. A change of one stop each way would double the exposure from ¼ second to ½ second, and halve the aperture from *f*/11 to *f*/16. This would have no effect on the quantity of available light received on the film, but would effectively halve the impact of the flash. The flash reading would still be *f*/11 as, due to the very short duration of the flash discharge (around ⅟₅₀₀ second), it is not affected by changes in these longer exposure times. A change of two stops each way would mean a 1-second exposure at *f*/22, thereby having the effect of reducing the flash output to one-quarter the power of the available light, which is the preferred power ratio of fill-in to dominant light sources. I suggest you use this ratio as your starting point for shooting the first instant-print to assess the actual effect of the mixed lighting in terms of intended results; and as a base for bracketing exposures on the film when you are happy with the instant-print image.

Figure 5.5 The evaluation of lighting ratio variants. Four instant-prints show different ratios of flash output to the strength of the available daylight. Print (a) shows an even balance of flash and available light: ¼ s at *f*/11. The interior appears uniformly lit, producing a flat image. In print (b), the effect of the daylight has been increased at the expense of the flash by one stop each way: ½ s at *f*/16. Print (c) shows the effect of a two stop difference each way, whereby the flash output is now one-quarter the power of the available daylight: 1 s at *f*/22. This is the preferred power ratio of fill-in to dominant light. For the purpose of exposure comparison, print (d) was taken with just the daylight, and no supplementary flash at all: 1 s at *f*/22. These examples demonstrate how subtle fill-in lighting creates a natural atmospheric balance on film between even, flat lighting and unrecordable contrast when using available light alone

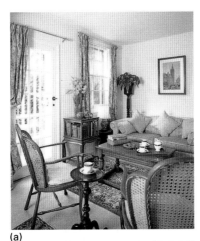
(a)

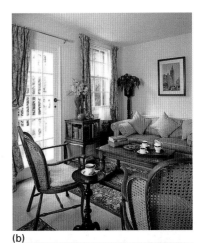
(b)

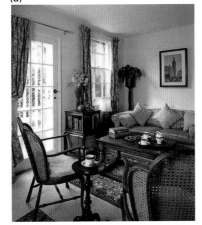
(c)

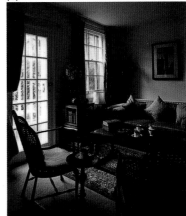
(d)

Instant-print assessment

The first instant-print test shot (on ISO 100 daylight-balanced film) should give a clear indication as to whether the image is more or less as you intended. If it is perfect, you can proceed with shooting the actual film. If, however, the instant-print is too dark, too light, or the mixture of lighting is unsatisfactory, make the necessary exposure and aperture adjustments that you feel will correct this and then shoot a further test shot. Shooting a second instant-print on a slightly different camera setting will also give you a clearer understanding of the actual effect that a half- or one-stop difference can make, thereby giving you a better idea of the extent to which further adjustments might change the image. The instant-print is an invaluable tool for getting your image near perfect before committing it to the real film, but it is a poor guide to both colour and focus (it is too soft to show up sharp detailing on medium format). However, if you are happy with the instant-print image, you will be delighted with the image on transparency.

Exposure trials

Suggested exposure trials for this example:

	Exposure (seconds)	Aperture
Original meter reading	¼	f/11 (flash reading)
Starting point: two-stop each way differentiation	1	f/22 (× 2 frames)
Further trials/brackets	1	f/19 f/27
	½	f/13 f/16 f/19
	2	f/22 f/27 f/32

I suggest shooting two frames of the likely perfect exposure, with half-stop aperture and exposure variations around this base.

These ten exposure trials will fill a roll of film on a 6 × 7 cm format, or will leave you with two spare frames for further trials on the square 6 × 6 cm format. You will find that most of the frames will be usable, but that they vary in both brightness and ratio of available light to flash. This gives the photographer and client a wide choice of slight variations in the final photograph, a choice which will be dictated both by usage and personal preference. It also demonstrates the advantage of flexibility that roll film holds over sheet film.

Apart from giving a more natural appearance to the room's illumination, another positive result of increasing exposure time and reducing the aperture size is that it progressively increases the depth of field to a point whereby everything in shot is likely to be in focus when stopped down for taking the actual photograph.

Image construction

While the results of the exposure trial used for this example are printed overleaf, the illustration in Figure 5.6 shows the basic lines of construction within the image chosen for this example.

Shot with a medium wide-angle lens, the camera position was chosen to maximize the impression of strong natural light by including two large window areas in the image. The natural light was supplemented by one flash unit placed just to the left of the camera position, between the camera and the window for the most natural effect. The shadow behind the plant stand in the corner is evidence of this, though because it falls to the right of the stand, our minds can imagine it was produced as a result of the bright light through the window. Care had to be taken to avoid a flash reflection in the painting on the wall.

Although not consciously thought out, the image has obeyed the Law of Thirds in its construction. The corner of the room lies close to the righthand vertical third, and the line is visually strengthened by the contrasting column of the plant-stand. The book-stand, the daffodils, the plant and the coffee-table all lie approximately at the intersections of the thirds.

The enhanced perspective produced by a wide-angle lens encourages the dynamic structure of the image. The eye is led into the picture from each side by opposing dynamic lines which meet at the book-stand. The meeting of these lines, approximately at an intersection of the thirds, makes this the immediate focal point of the image.

The addition of the coffee-cups and biscuits to the room not only adds further interesting detail but also helps to generate an atmosphere of relaxed and welcoming homeliness to the image.

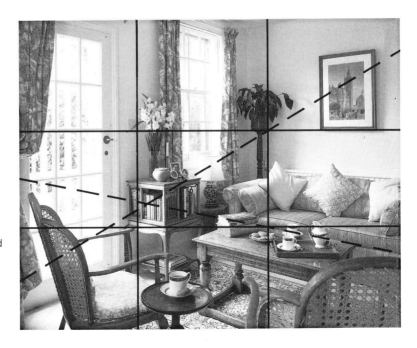

Figure 5.6 The solid lines drawn across the image used for the exposure trials in this chapter demonstrate how its construction obeys the Law of Thirds. The dotted lines show the basic dynamic structure of this composition. The meeting of these lines approximately at an intersection of the thirds makes the book-stand at that junction the immediate focal point of the image.

Figure 5.7 Exposure trial for the 'practical everyday method'. The exposures vary in accordance with the trials in the text. (Frame 1, bottom right, to frame 10, top left.) Notice how the lighting ratios change, and also the effects of increased and reduced exposure times

6
Technique Part 2: The critical precision method

Introduction

The 'critical precision method' differs from 'the practical everyday method' in several important respects. A different film is used; focusing is worked out to achieve perfect focus throughout the depth of the image; the necessary aperture to achieve that focus is calculated in advance; and the flash output is built up accordingly to cope with smaller working apertures. Colour balance also has to be checked and corrected as necessary.

Film

The specialist film for interior photography is a tungsten-balanced colour transparency film rated at ISO 64, as it has been specifically designed for long exposures between $\frac{1}{15}$ second and 30 seconds. This both enables the photographer to use small apertures to achieve maximum depth of field in the image and also gives enough time to fire the flash units several times to build up sufficient fill-in light for such small apertures. For most interior work where daylight is the dominant light source, an 85B colour correction filter is necessary over the camera lens. However, the density of this filter has the effect of reducing the effective film speed by one stop to ISO 32.

The initial setting up of the camera and lighting remains the same as for the 'practical everyday method'. It is at the point where you turn your attention to the final focusing that the 'critical precision method' becomes more complicated.

Focusing

The theory behind perfect focus throughout the depth of the subject being photographed is to establish the optimum plane of focus from which sharpness will extend in both directions to include the nearest and furthest elements of the picture, at a certain aperture. It is also important to find the largest aperture possible that will encompass this zone of sharpness, as the performance of even the best lenses tends to fall off at apertures smaller than $f/22$ due to diffraction. Using the largest aperture possible has the further advantage of minimizing the necessary flash output and exposure time.

The simplest way to do this is to measure the bellows displacement between the focus on the furthest and nearest elements of the image, and then set the camera to half the displacement measured. So first focus the camera on the furthest element (the far wall in an interior) and mark this position at the monorail, baseboard, or focusing knob. Then focus on the nearest element. The camera focus will increase and a second focus setting will be obtained. Measure the distance between the two displacements and set the camera at half this measured displacement. The optimum focus position for the desired depth of field zone has now been established. The corresponding working aperture needed to cover the required depth of field is found in the 'Linhof Universal Depth of Field Table' (Table 6.1). The appropriate minimum *f*-numbers for a given film format are listed for various bellows displacements.

Linhof Universal Depth of Field Table

Focus camera to far and near object points (also when Scheimpflug rule is applied) and measure extension difference in mm, using scale above. Look up this figure in appropriate format column and read off f/stop required to obtain the necessary depth-of-field on the same line at right. For intermediate values, use next smaller f/stop shown on the line below.

Set rear standard at half the displacement established.

	2¼ x 2¾ in.	4 x 5 in.	5 x 7 in.	8 x 10 in.	f – stop
mm	1,2	1,6	2,4	3,2	8
mm	1,7	2,2	3,3	4,4	11
mm	2,4	3,2	4,8	6,4	16
mm	3,3	4,4	6,7	9,0	22
mm	4,8	6,4	9,6	12,8	32
mm	6,7	9,0	13,5	18,0	45
mm	9,6	12,8	19,2	25,6	64
mm	13,5	18,0	27,0	36,0	90
mm	19,2	25,6	38,5	51,2	125
mm	27,0	36,0	54,0	72,0	180
mm	38,5	51,2	77,0	102	250

In close-up work, the f-stop taken from the table should be corrected as follows:

G = 6 f : open by ½ stop;	G = 2 f : open by 2 stops;
G = 4 f : open by ⅔ stop;	G = 1.5 f : open by 3 stops;
G = 3 f : open by 1 stop;	G = 1.3 f : open by 4 stops.

Explanation: G = distance of diaphragm plane to the forward ⅓ of the subject; 6 f = 6 x focal length of the lens employed.

Table 6.1 The 'Linhof Universal Depth of the Field Table' calculates the minimum aperture needed to cover the required depth of field, once the optimum focus position has been established. Use this as your working aperture for the 'critical precision method'

Universal Depth of Field Table

Table 6.1 shows different displacements at the same aperture for different formats because smaller negatives normally require a higher magnification. As a result, closer tolerances apply for calculating the depth of field available for critical sharpness. If neither the smallest possible aperture nor a Scheimpflug adjustment can produce sufficient depth of field to render the full depth of the image sharp, a smaller reproduction ratio has to be chosen by increasing the camera-to-subject distance or using a lens of shorter focal length.

Universal Depth of Field calculators

Universal Depth of Field calculators are available for some viewcameras. These work on exactly the same principle as described above and are more convenient as they are built into the camera without necessitating any further external tables. They consist of a moveable aperture scale on the rear focusing knob which indicates the working aperture for any required depth of field, and also the optimum focus position.

Multiple flash and multiple exposure

Once perfect focus has been achieved, and the working aperture deduced, it is time to take a light reading of the available light to determine the exposure for the working aperture. Let us assume that the working aperture was calculated as $f/22$ and the exposure required measured as 8 seconds at ISO 32 (that is, ISO 64 less one stop for the colour correction filter). If the flash reading is $f/5.6$ at this film speed, the flash output needs to be boosted to read $f/11$ for it to act as an adequate fill-in, two stops below the available light reading of $f/22$. To do this, one would have to fire the flash unit(s) four times during the 8-second exposure: once for $f/5.6$; twice (double the output) to boost it one stop to $f/8$; and then double that output, making a total of four times, to boost it a further stop to $f/11$. This is done most easily by firing the flash units manually with the flash meter, so long as the length of exposure is sufficient for the number of flashes needed. Otherwise, it should be done by multiple exposure: in this case, for example, four 2-second exposures with the flash unit(s) fired each time directly by the camera.

Having determined the optimum aperture and exposure, and calculated the necessary flash output, it is time to take an instant-print test shot to check that your calculations are creating your intended results. If using ISO 64 tungsten-balanced instant-print film, expose it just as you would for the transparency film, but with any slight exposure adjustments recommended on the pack to take account of the ambient temperature. If you choose to work with ISO 100 daylight-balanced instant-print film, remove the 85B filter for the test-shot and follow the calculations outlined below.

Exposure calculation between instant-print and transparency films of different speeds

Remember that our calculations are based on a film speed of ISO 32, whereas the daylight-balanced instant-print film is rated at ISO 100. If we keep the working aperture constant at $f/22$, the exposure time and flash output will need to be adjusted accordingly. The difference in film speed between ISO 32 and ISO 100 is almost exactly one and a half stops (one stop: 32 + 32 = ISO 64; one and a half stops: 64 + 32 = ISO 96; two stops: 64 + 64 = ISO 128). Because the instant-print is the 'faster', more light-sensitive, film due to its higher speed rating, the exposure time and flash output will have to be decreased by one and a half stops for the purposes of the test shot(s). Thus, a one and a half stop decrease in an 8-second exposure would be a 5-second decrease, creating a 3-second exposure for the instant-print shot (one stop decrease: $\frac{8}{2}$ = 4-second decrease; a further

half-stop decrease on the remaining 4-second exposure: ¾ = 1-second further decrease, making a total decrease of 5 seconds). A one and a half stop decrease in a four-flash output would be a two and a half-flash decrease, creating a one and a half-flash output for the instant-print shot (one-stop decrease: ½ = 2-flash decrease; a further half-stop decrease on the remaining two-flash output: ¾ = half-flash further decrease, making a total decrease of two and a half flashes).

So the ISO 100 instant-print is shot at *f*/22 with a 3-second exposure, and one and a half flashes (a little awkward, but quite possible for the purposes of the instant-print). Assuming you are happy with the result of this instant-print, you can now put the 85B colour correction filter on the lens and proceed to shoot the transparency film. As with the 'practical everyday method', bracketing is the best way to guarantee a perfect result, so below are the bracketing suggestions for this particular example, again assuming a 10-frame roll film.

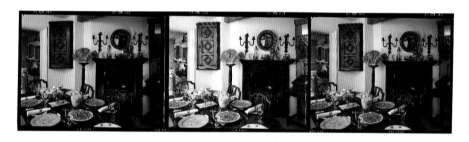

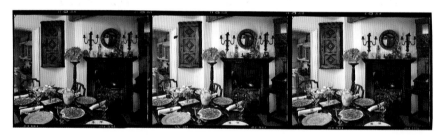

Figure 6.1 Exposure trials for the 'critical precision method'. The exposures vary in accordance with the trials in the text. (Frame 1, bottom right, to frame 10, top left.) The aperture remains constant throughout, so notice how the lighting changes with exposure time and flash output

Exposure/flash trials

Suggested exposure/flash trials for this example:

Aperture constant at *f*/22

	Exposure (seconds)	No. of flashes
Starting point	8	4 (*f*/11) (× 2 frames)
Further brackets	8	2 (*f*/8)
	8	6 (*f*/13)
	8	8 (*f*/16)
	8	12 (*f*/19)
	4	8 (*f*/16)
	6	4 (*f*/11)
	12	4 (*f*/11)
	6	8 (*f*/16)

Again, this allows two frames for the likely perfect exposure, and half-stop variations in exposure time and flash output around this base. While most frames should be usable, they will vary in terms of both brightness and ratio of the dominant available light to the fill-in flash. This gives the photographer and client a full choice for final reproduction, depending on usage and personal preference. Notice that the working aperture remains constant throughout at *f*/22, as this was the determined maximum aperture for perfect focus throughout the depth of the image, thus giving both perfect focus and optimum lens performance for the situation.

If the instant-print test shot is either too dark or too light, or the balance of dominant to fill-in light is not to your liking, then assess the necessary exposure and/or flash adjustments and make further test shots until you are completely satisfied with the result. A satisfactory instant-print should yield an excellent result on transparency. If working with ISO 100 daylight-balanced instant-print film, do not forget to increase the exposure time and flash output by one and a half stops to deduce the starting point for bracketing on the transparency film, and again remember to put the 85B filter over the lens.

Checking colour balance

Finally, the colour balance of the artificial light source(s) may need to be checked to ensure optimum colour rendition on the final transparency. This is done by using a colour-temperature meter which measures the colour balance of light in an interior and then calculates the colour correction and compensating filters necessary to balance the light to the film being used. You register the film-type into the meter, and then take an incident reading from the centre of the room. The relative responses of the three colour-sensitive photocells to this light are compared, displaying a read-out of any necessary filtration required. It is important to use as few filters as possible in front of the lens to retain optimum image quality.

Checking the colour balance of the available light in an interior is essential for critical colour rendition in situations of only artificial lighting – for example, tungsten and/or fluorescent. Where daylight is present in an interior, and especially if a window is in view, you must remember that any

filtration you put over the lens to compensate for the colour-casts of the artificial lighting will also discolour the daylight on the recorded image. For details on how to overcome such problems, see the next chapter.

Checking the colour balance is only of limited use for residential interiors where daylight is likely to be dominant. It is usually more important to maintain the same balance of available tungsten lighting to daylight between shots of the same room in order to retain the same atmosphere than it is to ensure perfect colour reproduction. A reddish glow from a table lamp, for example, can create a desirable warmth in the picture adding to the rich essence of the interior. Personal preference and the use for which the photographs are being taken should guide you in these matters.

Professional etiquette and insurance

As a conclusion to these two chapters on the fundamental techniques of interior photography, it seems appropriate to briefly outline some guidelines to the professional etiquette that all photographers of interiors should follow. This is important both as a matter of natural courtesy to the client and/or owner of the property being photographed and to demonstrate an attentive respect so as to create the best possible impression to further your chance of future commissions.

These guidelines include being polite and respectful of the owner's property on a shoot – which could be the personal and private sanctuary of the owner's home – and always to carefully rearrange every interior back to its original state after being photographed. If possible, remember to bring an old plastic carrier-bag with you in which to collect and take away your rubbish. Film papers and boxes, instant-print papers and empty packs are messy and quickly mount up.

While you should exercise the greatest care with other people's possessions, accidents can happen and could prove very costly without adequate insurance cover. For example, a flash unit mounted on high with an umbrella attached could topple over onto a fragile and expensive antique if someone were accidentally to trip over the cable. When working on other people's premises make certain that you have proper professional indemnity and third-party insurance to cover you in such an unfortunate event. Such a policy, along with comprehensive insurance for your photographic equipment (on location, in transit and back at base), should provide you with greater confidence and peace of mind.

7
Mixed lighting conditions

Introduction

The previous two chapters have basically been dealing with an average interior that is illuminated predominantly by daylight, with supplementary fill-in flash. Any artificial room lights or lamps have been treated as either negligible or atmospheric.

However, that is not always the case. The artificial lighting element can form a very significant, sometimes dominant, part of the overall available light. In such circumstances, the colour-cast it would create, without filtration, on a film balanced for white daylight would be unacceptable for most uses. Likewise, if tungsten-balanced film was used in an interior of predominantly tungsten lighting, any daylight or flash would create an unpleasant blue colour-cast on the film. The following sections will outline various techniques to overcome these problems.

One such technique is to divide the total exposure of a single film-frame into different parts. This is known as 'multiple exposure'. When using this technique it is essential to keep the camera absolutely steady throughout the whole process. Even the slightest movement between exposures can cause a double image on the film.

I should mention that for the purposes of the 'practical everyday method', it is still sometimes possible to achieve acceptable results by illuminating the foreground with flash (the effect of which is enhanced when using a wide-angle lens due to the exaggeration of perspective that this lens creates). You then 'burn in' and make dominant the available light without filtration, so long as daylight forms a significant part of that light, all on a single exposure. However, for optimum colour rendition required by the 'critical precision method' this would be unacceptable.

Part 1: Mixed daylight and tungsten

Many residential interiors, and some offices, are illuminated by a combination of daylight and tungsten lighting in the form of ceiling lights or table lamps. This presents a problem due to the different colour temperatures of the different sources. For example, filtering specifically for the tungsten lighting when using a daylight film will cause the colour of the white daylight to appear blue on film. There are several alternative methods for dealing with such mixed lighting situations, depending on the effect being sought.

The first and simplest method is to leave all the tungsten lamps switched off, and work with just the dominant daylight and fill-in flash – a technique that is preferred by some interior-design magazines. If the tungsten lamps are to appear lit in the photograph, the ideal method for optimum overall colour rendition on the transparency is to use a multiple exposure. As a general rule for any mixed lighting situation, the total exposure of a single film frame can be divided into as many parts as there are different types of light source in the interior to be photographed, assuming that each source can be controlled independently of the others.

For this situation of mixed daylight and tungsten, we shall divide the exposure into two: the first part for the daylight and any fill-in flash, with the tungsten lights switched off; and the second part for the tungsten lights only, with the windows blacked out. Using tungsten-balanced film, the first part of the exposure for the daylight and flash would have to be filtered with an amber 85B colour correction filter. The exposure time for that part of the overall exposure, and also the flash output, would have to be increased by one stop, to take account of the strength of filtration.

A light meter reading should be taken with full available light (i.e. with both the daylight and the tungsten lights switched on) for a specified working aperture. If the existing balance of daylight to tungsten is to be maintained for the most natural appearance on film of the actual situation, then the exposure reading taken should be used for both parts of the exposure independently. If a different balance between the two light sources is preferred, then the exposure time for each part can be adjusted accordingly.

The first part of the exposure for the daylight is likely to be supplemented by fill-in flash. Depending on the flash output necessary for the working aperture, the flash can be fired any number of times to reach the required output either by firing it manually, if exposure time permits, or by dividing the exposure time into equal parts and letting the camera trigger the flash with each of a multiple of exposures.

For example, let us assume an exposure reading of 10 seconds for a working aperture of $f/22$ when using a tungsten-balanced film rated at ISO 64. A flash reading of $f/6.7$ was taken at full output. In order to be an effective fill-in, the flash would have to be fired twice to increase its effective output by one stop to $f/9.5$, and half of this overall output again, i.e. one more flash, to achieve a further half stop for an $f/11$ reading. This would mean firing the flash three times in all to create an effective output of $f/11$, which would be the recommended fill-in ratio of one-quarter the power of the available light.

The 10-second exposure and three-flash output must next be increased by one stop to take account of the strength of the 85B filtration. A one-stop increase requires a doubling of exposure time and flash output, so the exposure time would become 20 seconds and the flash output would become six flashes.

The daylight/flash part of the overall exposure could therefore be achieved, most sensibly, by firing the flash manually six times during the 20-second exposure. Alternatively, for the purpose of illustrating the point, this could also be achieved by multiple exposure in the following way: five exposures of 3 seconds each, and a sixth exposure of 5 seconds, each time triggering the flash unit(s) at full power. The tungsten part of the exposure would be for a straight 10 seconds.

Unless suitable black blinds are fitted for easily blacking out the windows between each shot, only the physical masking of each window

with black paper would make this ideal method possible. The drawing of curtains does not have the same effect, as the colour and pattern of the curtain is likely to appear in ghostly outline across the window. The curtains would also have the strange appearance of being both open and closed at the same time. When shooting 10 or 12 frames on a roll of film in an interior with several windows, this can become impractical.

Figure 7.1 Mixed daylight and tungsten. A compromise solution was used to record this image. This involved a double exposure, with full illumination from both the tungsten kitchen lighting and the daylight throughout. The first part of the exposure was with an 80 A blue filter to partially correct the colour of the tungsten to match the daylight film. The second part was for the daylight and fill-in flash, with the filter removed

The more likely scenario is that it will not be possible to black out the windows effectively for the tungsten part of the exposure. In such circumstances, only the best compromise can be achieved. Again, you divide the exposure into two parts, filtering with the appropriate colour correction filter for one part of the exposure depending on the film-type being used, but maintaining full illumination from both light sources throughout the duration of the whole exposure. The proportion of the exposure that is filtered will depend on the relative intensity of the two different sources. With daylight-balanced film, if the photographer overestimates the amount of tungsten lighting and gives too large a proportion of the overall exposure with an 80A filter, the result will be an overall blue colour-cast, creating a cool atmosphere in the photograph. Conversely, an underestimation of the proportion of tungsten lighting will lead to a photograph with an overall warm, amber colour-cast.

In such circumstances, if the balance of the tungsten is more dominant than the daylight, and you choose to redress this balance, you can do so by switching off the lamps for a portion of the exposure, and correspondingly increasing the exposure for the daylight. Alternatively, the lights can be dimmed cautiously. I say 'cautiously' because this has the less desirable effect of lowering the colour temperature of each individual lamp, i.e. making the glow from the lamps appear more orange and less yellow on daylight film. Experiment on instant-print film to check for the most

natural appearance of the dimmed lamps, and adjust them as necessary to achieve the best compromise.

If dimmer switches are not available, and it is awkward to turn off the lights for a portion of each exposure, you could create a more even lighting balance between the daylight and the flash, thereby decreasing the relative effect of the orange tungsten lighting. This will, however, reduce the natural atmosphere of the image, making the general appearance of the lighting flatter. It must be remembered that a certain level of orange glow from lamps can enhance a photograph by giving it an added warmth.

Finally, it is possible to purchase special blue-coated bulbs that can be used to replace those in existing lampholders. This has the effect of whitening the light from these artificial sources, in order to approximate their colour temperature to that of the daylight. Alternatively, large rolls of gelatin filter are available for covering windows in order to balance the colour of the daylight to that of the tungsten lights.

Part 2: Mixed tungsten and fluorescent

When an interior is illuminated by a mixture of tungsten and fluorescent lighting – usually in a commercial or industrial building – the photographer should use a double- or multiple-exposure technique similar to the ideal method outlined in the previous section for daylight and tungsten. Again, an overall light measurement should be taken with both light sources switched on, for a specified working aperture. Unless tungsten photographic lighting is used as a supplementary light source (in which case it should also be switched on when taking the light reading), any flash fill-in will have to be filtered appropriately. However, it is likely that such conditions of purely artificial lighting will be sufficiently evenly lit not to warrant any extra photographic lighting.

This light reading will give the necessary exposure for the photograph, and will be the basis for each part of the double exposure as each light source is switched on and off independently. Using this same exposure for each part of the overall exposure will maintain the existing lighting balance of tungsten to fluorescent as they naturally appear.

Before the double exposure can take place, the appropriate exposure increase for the fluorescent part of the exposure must be calculated to take account of the necessary filtration, assuming a tungsten-balanced film. For example, using a tungsten-balanced film rated at ISO 64, a light meter reading indicates an exposure of 10 seconds for a working aperture of $f/22$, with all the lights switched on. The tungsten part of the exposure will therefore be a straightforward 10-second exposure without filtration. The fluorescent lighting in this example is White Fluorescent. The colour compensation filters necessary to balance the colour of the fluorescent lighting to the tungsten-balanced film is CC 40 M + 40 Y, as read from Table 7.1. This filtration requires an exposure increase of one stop. Therefore, the fluorescent part of the exposure will have to be double the 10-second meter reading, making a 20-second exposure.

The double exposure would therefore work as follows. Switch off the fluorescent lights, and expose the film at $f/22$ for 10 seconds without filtration. Next, reset the shutter, place filtration to the value of CC 40 M + 40 Y over the lens, switch on the fluorescent lighting, and switch off the tungsten. Make a further 20-second exposure on top of the first, under these conditions.

Table 7.1

Colour compensation filters for fluorescent lighting		
Type of lamp	Daylight balanced film	Tungsten balanced film (type B)
Daylight	40 M + 40Y + 1 stop	85B + 40M + 40Y + 1⅔ stops
White	20C + 30M + 1 stop	60M + 50Y + 1⅔ stops
Warm white	40C + 40M + 1⅓ stops	50M + 40Y + 1 stop
Warm white de luxe	60C + 30M + 2 stops	10M +10Y + ⅔ stop
Cool white	30M + ⅔ stop	60R + 1⅓ stops
Cool white de luxe	20C + 10M + ⅔ stop	20M + 40Y + 1⅓ stops
Colour compensation filters for other types of discharge lighting		
Lucalox	70B + 50C + 3 stops	50M + 20C + 1 stop
Multi-Vapour	30M + 10Y + 1 stop	60R + 20Y + 1⅔ stops
De-luxe white mercury	40M + 20Y + 1 stop	70R + 10Y + 1⅔ stops
Clear Mercury	80R + 1⅔ stops	90R + 40Y + 2 stops
Sodium Vapour	Not recommended	Full correction impossible Most neutral appearance without filtration

Table 7.1 Filters required to compensate for fluorescent and other forms of discharge lighting. Necessary exposure increase in f–stops is given

Part 3: Mixed fluorescent and daylight

With ideal conditions, the best solution for photographing interiors of mixed fluorescent and daylight is again the double-exposure technique: the first part for the daylight alone; and the second part for just the fluorescent with the daylight blacked out. However, interiors illuminated by this mix of lighting are often large, open-plan offices, making it impossible to control the daylight. Working on daylight-balanced film without filtration would create an unpleasant green colour-cast across the image. Filtering for the fluorescent would make the daylight coming through the windows appear magenta in colour.

Several alternative solutions are possible. One could, for example, leave the fluorescent lighting switched off and work with a combination of

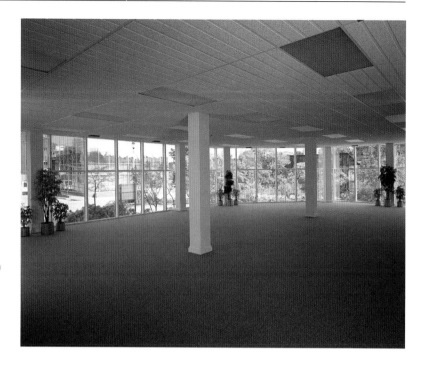

Figure 7.2 Photographed with a combination of daylight and flash, the fluorescent lights were switched off to prevent the problem of an unpleasant green colour-cast. The use of a colour compensating filter with the fluorescent lights switched on would have changed the colour of the daylight through the windows

daylight and flash lighting. Conversely, one could wait till nightfall in order to work with the fluorescent lighting alone, using supplementary flash lighting filtered through appropriate green gels, where necessary. The appropriate filtration for the fluorescent lighting in use would, of course, have to be placed over the camera lens.

One could also shoot a compromise double exposure, shooting half the exposure with filtration and half without, with full lighting for the whole exposure. Depending on the relative strength of each source, the duration with and without filtration can be adjusted accordingly.

The best results can be obtained by the time-consuming business of covering each individual fluorescent tube with a sheet of gelatin daylight conversion filter. This would have the effect of balancing the colour of the fluorescent light with that of the daylight.

8
Problem interiors

Introduction

Problem interiors are those that deviate from the typical average interior used to illustrate Chapters 5 and 6. This deviation can be of size, structure or lighting. Difficulties can also arise with interiors that have no electricity or no furnishings. Those full of reflective surfaces require certain necessary precautions to be taken, to prevent unsightly umbrella reflections from appearing in the image. Various solutions to these problems are outlined to assist you in the day-to-day practice of this type of work.

Large interiors

Large interiors include open-plan office areas, factories, industrial warehouses and churches for which the output from a couple of flash units could appear totally ineffective. There are three possible methods for dealing with such interiors. The first and simplest is to use the available light only. The second is to choose a camera position that enables you to hide several flash units within the picture area, thereby using the flash either as the dominant source or as a very effective fill-in. The third method is what is known as 'painting' with light whereby the photographer literally paints the interior with light from a flash or tungsten source while the camera shutter remains open.

Available light

Photographing a large interior with available light only is both the simplest and fastest method, and often quite adequate for the use for which the photograph is being taken. For example, a photograph of a warehouse for a property brochure can often end up being printed around the same size, if not smaller, than the original transparency. This would not warrant extensive subtle photographic lighting in terms of either quality or time. In fact, many such warehouses have very effective skylights along the length of their roofs which provide wonderfully even sources of white illumination over the whole interior that can often be supplemented further by opening their massive doors. If they do not have skylights, they will

have some form of artificial lighting which with simple filtration should render an evenly lit image of sufficient quality. Problems only arise when the large interior has both windows and artificial lighting, as discussed in the previous chapter.

Figure 8.1 Being such a large interior, this warehouse was shot using available light only. The skylights along the roof provide excellent even illumination, supplemented further by opening the massive warehouse door at the far end

Hidden flash lighting

To achieve the cleanest and brightest possible image, flash lighting has to be introduced. This can create a predomination of white light and avoids, on film, the burning out of the light sources in the picture. Furthermore, it gives the photographer maximum control over the lighting. The picture can either be deliberately composed to enable flash units to be placed just outside the picture area (though this can be difficult with large interiors) or flash units can actually be hidden within the picture area itself. This method can be used with a double-exposure technique: one fast exposure for the flash and a second for burning in and filtering the available light when that light is predominantly artificial.

The photograph of the church in Figure 8.2 was illuminated by two flash units either side of the camera fired directly at the dark roof timbers, with a third unit hidden behind the organ on the left. The flash from this third unit was reflected off a white umbrella to illuminate the important altar area, and although hidden, was still sufficiently sensitive to be triggered by the flashlight from the two units either side of the camera. A long exposure was required for both burning in sufficient daylight and firing the flash enough times for the necessarily small working aperture. Because available tungsten lighting adds a rich warmth to woodwork, I left the church lights switched on for the full duration of this exposure.

Flash units can be concealed behind pillars or furniture, or hidden in doorways so long as nothing of the unit or its cabling is visible in the final image. The sight of any equipment, cabling or photographic lighting reflections in a photograph destroys its natural appearance and should be avoided at all costs.

Flash can be bounced off anything white, not necessarily an umbrella if there is insufficient space for it or it is causing an unsightly reflection. It can be bounced off a wall, the junction of the wall with the ceiling, white card, or even woodwork if you are happy with a warmer light. For illuminating small dark areas within the picture area, a portable flashgun with a slave-unit attached (a flash-sensitive triggering device) is a handy and very easily hidden source of flash light without any cabling.

'Painting with light'

When you require even illumination of a large, dark interior without having to set up and conceal many flash units within the picture area, it is possible to use a very long exposure during which time you literally 'paint' the interior with light from either tungsten lamps or flash units. This creates shadowless illumination and requires the photographer to walk around the interior painting with the light source or firing the flashes from within the picture area itself.

In order to make this long exposure, use the 'T' shutter setting on the lens as, once fired, this will hold the shutter open until the cable release is pressed a second time. If there is no 'T' setting on your lens, use the 'B' setting in conjunction with a locking cable release. Once fired, the screw-lock will hold the shutter open while you are away from the camera. Releasing it on your return will close the shutter.

For example, I used this technique to illuminate the church in Figure 8.3. The church itself was suitably dark and gloomy with the lights switched off, which enabled me to use a 60-second exposure at $f/16$ with an 85B filter over the lens. This gave me just enough time to get around the full interior, with negligible reciprocity failure on tungsten-balanced film rated at ISO 64. If the ambient light is too bright for a long exposure, neutral density (ND) filters can be used over the camera lens to reduce the intensity of light reaching the film-plane (see Table 9.1). However, they also reduce the intensity of the flash light reaching the film, which means more power will be needed from the flash units. This is most simply done by firing them more times within the extended exposure time.

The painting sequence I used is illustrated in Figure 8.4. It is essential to work out the most appropriate painting sequence in advance in order to illuminate the interior evenly and efficiently in the limited time available.

It is practical to position beforehand two or three flash units, or tungsten lamps, in concealed positions, in order to keep power cables to manageable lengths and prevent their image appearing on film. The placing of these units will be dictated to a large extent by the location of power points. The church in Figure 8.4 had only two power points: one in the nave and one in the chancel. Concealed places near to these points were therefore used to hide the units when not in use during the exposure. Their slave-units were switched off so they were not triggered by other flashes.

As already mentioned, this technique involves you walking around the interior during the exposure. The golden rule, therefore, is to wear dark

Figure 8.2 Spexhall Church, Suffolk. This interior was illuminated by two flash units placed either side of the camera, fired directly at the dark roof timbers. A third unit was hidden behind the organ on the left to light the altar area, bouncing the flash off a white umbrella. Despite its concealed position, it was still sufficiently sensitive to be triggered by the other two flash units. The tungsten church lighting was left switched on for the duration of the exposure to add a rich warmth to the woodwork. (N.B. The film plane was perfectly vertical for this shot. The suggestion of diverging verticals lies within the structure of the old building itself!)

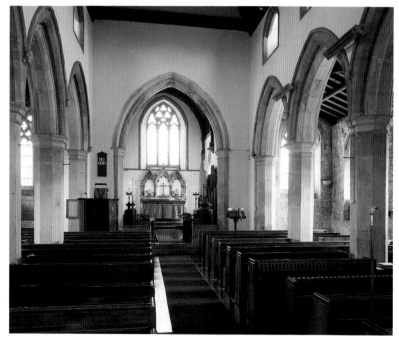

Figure 8.3 Mursley Church, Bucks. A 60-second exposure was used during which time I 'painted' the interior with light, walking around within the picture area firing a flash unit. I wore dark clothes and kept moving throughout to prevent my own image appearing on film. My 'painting' sequence is illustrated in Figure 8.4

clothes and keep moving so as not to record on film. Fire the flash as you move, and make sure the unit is never aimed in the direction of the camera.

The flashing, or painting, must be balanced between the two sides of the interior, assuming a symmetrical arrangement, and as evenly as possible in all circumstances. Avoid firing the flash or painting the tungsten light too

close to the foreground furniture when illuminating more distant areas, as you do not want any element artificially burnt out on the image.

Use the flash or tungsten direct, and determine the exposure by metering the ambient daylight for the predetermined working aperture. If it is less than 60 seconds, it may be worth reducing the aperture size further to increase the exposure time. Once established, you can then work out the necessary amount of flashes, or length of painting time, for each area, in order to create effective fill-in lighting. Base this last calculation on average flash or light readings from one of the units across two different distances, one short and one longer, that are likely to be used for the illumination.

The *f*/16 aperture for the church example effectively required a light output for an *f*/22 aperture to account for the approximate one-stop exposure increase necessary for the strength of filtration. For the flash to act as a fill-in, the output would have to be suitable for an aperture two stops wider than this, i.e. *f*/11, to reduce its effect to a quarter that of the ambient daylight. To achieve this output, I fired the flash twice for the shorter distances and four times for those further away, but never with clinical precision as I was moving throughout.

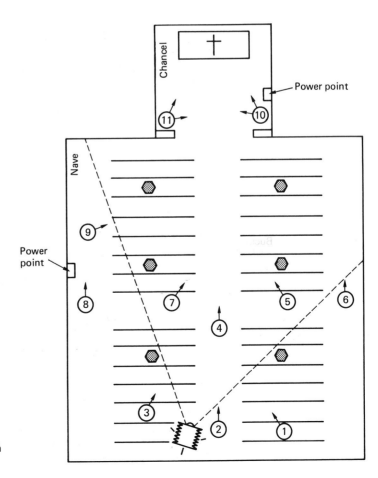

Figure 8.4 The 'painting' sequence used to photograph Mursley Church in Figure 8.3

The strength of this technique is that it enables you to illuminate very large areas with a minimum number of photographic lights. Its corresponding weakness, however, is that inevitably it is not 100% accurate either in terms of exposure or perfectly even lighting, all of the time. For this reason, it is most effective as a fill-in form of lighting where its output is subsidiary to the dominant daylight. This has the added advantage of retaining the most natural appearance of the interior, and demands the minimum flash output.

Examine the effects on instant-print film tests very closely before exposing the actual transparency or negative film, and use the instant-print film as a valuable secondary exposure guide. Bracketing with this technique is awkward, so I would recommend having transparency films 'clip tested' instead.

Clip testing

'Clip testing' is a useful facility offered by professional laboratories in order to achieve a perfect result on film so long as reasonably accurate, consistent exposures were maintained throughout the whole roll of film. When a film is clip tested, approximately the last frame is cut off the film and processed separately in the normal way. The result is viewed and assessed for perfect exposure. If the clip test is perfectly exposed, the rest of the roll can then also be processed normally. If the image on the clip is slightly over- or under-exposed, the variation from perfect exposure is estimated in f-stops and the film development adjusted accordingly. A further clip test can then be taken to confirm the adjustment if you are not absolutely confident of the judgement that has been made. However, each clip test eats further into the film, reducing the number of frames left for the perfect processing.

Film development time can either be shortened ('pull-processing') if the clip test was over-exposed, i.e. too bright, or lengthened ('push-processed') if the clip test was under-exposed, i.e. too dark. Push- or pull-processing by up to one stop should yield excellent results, correcting exposure within what is effectively a two-stop band around the perfect exposure. Wider than this, contrast is reduced with pull-processing with colours shifting towards blue. Conversely, with push-processing, contrast is increased along with graininess and fog levels, and colours shifting towards red.

The only minor disadvantages to clip testing are that it doubles the process time as the two parts of the film are processed separately, and it incurs a little extra cost. It should, however, yield a greater quantity of correctly exposed images per film than that achieved by bracketing alone, but is only useful when conditions of lighting and exposure are kept constant for the whole film.

The assessment of by how much the clip is over- or under-exposed can either be undertaken by the photographer (which will necessitate a further visit to the laboratory) or by the technicians at the laboratory. The instruction for the latter option is known to the laboratories as 'clip, judge and run' when you leave your film for processing.

Small interiors

The first problem with small interiors such as bathrooms, cramped kitchens and the like is finding the best position (often the only position) from which to take the photograph, in order to include enough of the elements in the room for it to yield a sensible, representative image of that interior. This can still be a problem with even the widest-angle lens.

Having found that position, the next problem is to actually erect the tripod within an inevitably confined space. Often the doorway is the best place to work from, as the camera can be placed as far back as possible to the point of maximum room-coverage (without clipping the door frame). You will also be less cramped as you will be actually standing in another room.

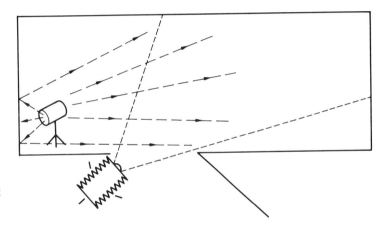

Figure 8.5 Photographing a small interior can be problematic due to lack of space. Placing the camera in the doorway and tucking a flash unit into the corner of the room can provide an effective solution

Having set up the camera in the most suitable position under the circumstances, lighting is the next consideration. Two basic options are open to you. First, you can use just the available light if this is all artificial and can be easily filtered (as in a small internal room); or second, you can use flash as either a dominant or fill-in light source. The first option is obviously the simplest, quickest, and often the most effective. The problem with the latter is where to place the flash unit in such cramped conditions without being visible from the camera position, and without causing any unacceptable umbrella reflections. Often the flash unit can be tucked into a corner either just within the room, if the camera is in the doorway (see Figure 8.5), or right up beside the camera if the camera is actually in the room.

There is often not room for an umbrella reflector, but this is no disadvantage if the wall and/or ceiling are white as it is usually more subtle to bounce the flash off the junction of the wall with the ceiling. This is because the flash light will be coming in from a similar angle to the way it would have been reflected off an umbrella, but without any possibility of an ugly umbrella reflection. The reflection (if there is one) of a glow off the far wall is much more aesthetically acceptable – see Figure 8.6.

If flash is to be used, the best technique is to use it as a fill-in. If the interior is otherwise completely artificially lit, the best results are obtained

by using a double exposure: one fast exposure just for the flash (and with the artificial lights switched off if possible); and a second longer exposure with the lights switched on and the appropriate filtration over the lens. Burning in the available light without filtration will only create an unpleasant colour-cast over the whole image.

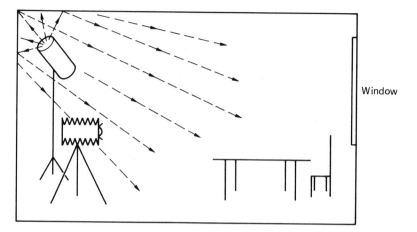

Figure 8.6 Where space is limited within a small interior, or where an umbrella reflection in a window or picture is inevitable, bouncing the flash off the junction of the wall and ceiling is an effective alternative. Any reflection this might cause will be more subtle, and therefore more aesthetically acceptable

Empty interiors

Empty interiors are always a challenge. In my experience they frequently seem to be recently developed, large open-plan office areas with a dull-coloured carpet, fluorescent lighting, and a series of structural pillars. The combination of pillars and lights can be used to reasonable effect to create an impressive perspective shot, with the diminishing pillars and receding rows of lights leading the eye into the picture from both sides. This is best achieved by standing approximately a third of the distance along the wall from the corner, to include three walls in the final image.

While such shots are suitably effective for the purpose for which they are usually used, they can be dramatically enhanced – as can any photograph of an empty interior – by direct sunshine creating abstract window patterns across the otherwise plain floorspace. The effect of these impressive patterns not only suggests a permanently bright and sunny interior but also breaks up the empty space with an abstract dynamism similar to that created by furniture in a room. This works both for a general view of the interior and also for an interesting detail shot of a window, or row of windows, with their corresponding sunshine patterns. Such patterns are richest in colour, longest, and reach furthest into the room either early in the morning or late in the afternoon, and in the winter months due to the lower elevation of the sun.

Light readings for interiors with direct sunshine should be taken as usual of the general ambient light in the interior, and not from the sunny areas. This is because we want the sunny areas to record brightly, even slightly burning out on the film, as this is how they appear to the naked eye. If the sunshine patterns appear too burnt out on the instant-print test shot, you can always reduce the exposure time (or aperture size, if appropriate) and correspondingly boost the flash output to effectively reduce the brightness of the direct sunshine. I have found, however, that due to the extra brightness generally expected from such sunshine patterns, it is often most

Figure 8.7 The perspective of pillars and rows of ceiling lights can add an abstract interest to a modern, empty interior

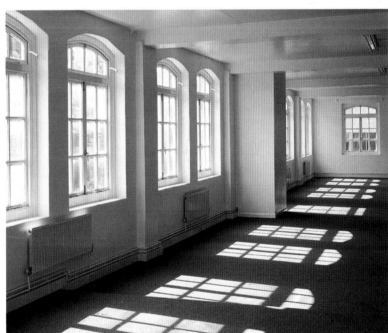

Figure 8.8 Sunshine is the ultimate saviour in an empty interior. The window patterns created by direct sunshine can break up the space with an abstract dynamism similar to that created by furniture in a room

effective to use only the available sunlight to illuminate these interiors, with no extra photographic lighting and the artificial room lights switched off. The brightness bouncing off the floor from the sunshine patterns tends to produce adequate and very natural fill-in lighting of its own.

In summary, to get the best out of an empty interior it is worth choosing a day with full sunshine (which will, of course, help with any exterior work you might also be doing). With the help of a compass or plan of the building, work out a shooting sequence that makes the best possible use of that sunshine.

No electricity

When you have to photograph sites which are either not fully completed or which have been unoccupied for any length of time it is likely that either the electricity has not yet been installed or it has been disconnected awaiting a new tenant. In either circumstance, you are left with the limitation of being unable to use your mains-powered flash units.

These circumstances seem to arise most frequently on commercial sites with large interiors. The only realistic option open to you is to stretch the available daylight as far as possible. Allow the window areas to burn out, if that is necessary, to create sufficient illumination for the interior to be clearly visible. The use of a portable flashgun from the camera position can brighten up the foreground with exaggerated effect when using a wide-angled lens, due to the perspective distortion that this lens creates. However, it is insufficient in itself to fully illuminate the interior and there are likely to be few concealed positions from which to 'paint' with it.

This appears to contradict the principle of 'fill-in', i.e. using supplementary photographic lighting to reduce the contrast of daylight to recordable levels. However, I suggest it merely as a practical measure to achieve a necessary result even though it will not yield the high-quality results of the fill-in technique.

In a small to average size interior, on the other hand, it is possible to use a portable flashgun with suitable effect. It can be used as either a direct fill-in or bounced off a wall or ceiling. Its output can be boosted by firing it several times either on a long, timed exposure, or by using several shorter exposures on a single frame to build up sufficient flash output to achieve satisfactory fill-in lighting.

Reflective surfaces

Reflective surfaces always provide a challenge for the photographer. Working out a way to overcome the problem of umbrella reflections, or even the reflection of the photographer (in a small mirrored bathroom, for example), can be a time-consuming and precise business. This section will outline a few helpful techniques to deal with such problems.

It is important to remember that light travels in straight lines and reflects off any flat surface at the same angle to the surface as the incoming light, but in the opposite direction (see Figure 8.9). For the flash unit not to cause unsightly reflections in a shiny wood-panelled room, therefore, you would have to place yourself in one corner of the room, shooting towards the

Figure 8.9 Light travels in straight lines and reflects off any flat surface at the same angle to' that surface as the incoming light, but in the opposite direction. This is essential to keep in mind when placing lights, in order to avoid reflections

Figure 8.10 Reflective surfaces. Placing the camera and flash unit(s) in one corner and shooting towards the opposite corner avoids the problem of reflections in a shiny wood-panelled room, as shown in diagram (a). A less diagonal position, as in diagram (b), would cause the flash to be reflected back towards the camera, causing obvious light spots on the panelling

(a) Correct (b) Incorrect

opposite corner, with the flash unit(s) beside you (see Figure 8.10). This will prevent any direct reflections from coming back towards the camera. Reflections from window light are usually quite acceptable as it is a natural light source.

The same principle applies to other reflective surfaces: paintings, picture glass, windows in the picture, etc. Some modern offices have glass wall partitions on two or three sides, with a window on the fourth. These can cause havoc with secondary and tertiary reflections bouncing around the room, even if you have been careful to position yourself so as to avoid any direct reflections.

Where wall-mirrors present a problem, as in small bathrooms, the photograph of the interior can be taken from an angle looking into the mirror itself, to include the area surrounding the mirror as well (see Figure 8.11). This effectively transforms the problem to your advantage. Photographing into the mirror from an angle, including the handbasin in the foreground, not only creates an unusual and imaginative shot but also enables you to include most of the significant elements within the room which would otherwise be impossible to achieve. In other words, your final image will be an original, exciting photograph that includes the fullest possible flavour of that interior. There will also be no problem reflections as you are using the reflective surface itself as part of the photograph.

Figure 8.11 Large mirrors in small interiors, such as bathrooms, can be problematic. It is possible, however, to use them to your advantage by photographing the reflection of the interior in the mirror from an angle. By including the basin, or area surrounding the mirror, this method can sometimes enable you to include all the significant elements within the room that would otherwise have been impossible to achieve

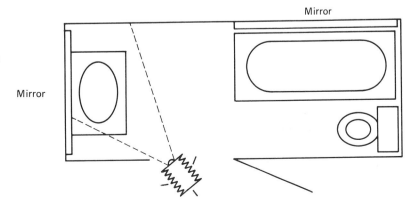

If you have the problem of an umbrella reflection in a picture glass there are two possible solutions. Either shift the offending flash unit sufficiently so that it is just not reflected or remove the picture from the wall if it is neither too significant nor leaves an unsightly mark on the wall.

Poor daylight

There are times when interiors have to be photographed without the perfect conditions of sunshine or even bright daylight. Pressure on a photographer's time and unpredictable weather conditions make this inevitable. All is not lost, however. There are two possible paths to follow to create the impression that there is a bright day outside.

First, and most simply, is to take an available light reading in just the same way as you would on a bright day. You will need a longer exposure than usual, which does not present a problem so long as that exposure falls within the tolerance of the particular film that you are using. You can then place an 81B 'warming' filter over the camera lens to warm up the colour of the otherwise cold, dull-grey light, as in Figure 8.12. This will create on film the appearance of warm, bright and diffuse light filling the room. It will, of course, also warm up the colour of any fill-in flash. This, however, is only very subtle and usually enhances the atmosphere, especially of a residential interior, by giving it an added welcoming warmth. Once again, when using any filters, do not forget to increase the exposure by the appropriate factor.

The other possibility, if the room to be photographed is reasonably small, is to place a tungsten lamp outside the window to act as an artificial sun. This will have the added effect of creating sunny window patterns across the interior. While natural sunshine would usually be the preferred choice, it does have the added advantage of being totally under the control of the photographer. Whereas the sun is constantly moving (and it is amazing just how fast it does move when you are busy setting up the camera, taking light readings and shooting instant-prints!), the tungsten light is obviously stationary for as long as the photographer requires it, and it can never disappear behind clouds! It can be angled from any direction to simulate any chosen time of day. It can also be filtered to varying degrees, with the appropriate combination of blue gels, to suit the angle chosen or amount of warmth desired. The higher the angle, the whiter the light; the more horizontal the angle, the more orange the light should be if it is to adequately simulate the real sun.

Tungsten lamps powered at between 1000 W and 2000 W are suitable for this work. The reason this alternative only really works well in small interiors, or for details of interiors, is because the light fall-off in a large interior would look unnatural, and would also require one lamp for each window in shot, set at precisely the same angle, and taking great care to avoid any double shadows.

(a)

(b)

Figure 8.12 The problem of poor daylight can be overcome with the combination of a longer exposure and an 81B 'warming' filter. Photograph (a) was taken on an overcast day, with a longer exposure alone. Photograph (b) was taken at the same time, but with the 81B 'warming' filter added. The amber/sepia tone of this filter tends to enhance the rich atmosphere of traditional residential interiors

Figure 8.13 A half-landing on a staircase often provides the best vantage point for a dynamic picture of its construction: the bannister rises up from the bottom of the image and the stairs lead on up to the top

Staircases and stairwells

Staircases can initially appear problematic: they can look somewhat dull and uninspiring from ground level. However, there are certain places on most staircases from where one can create some of the most interesting abstract photographs possible in the realm of interior photography.

The best place from which to photograph a staircase with a double flight of stairs is from a half-landing, using a wide-angle lens. From this point you can embrace within a dynamic abstract composition both the bannister rising to your level and the stairs leading up away from you. This both yields the best interpretation of the structure of the staircase and prevents any problems of converging verticals. Lighting such shots is best done from both the floor below and the floor above to prevent either part of the staircase disappearing into a shadowy abyss.

A dramatic technique for photographing a stairwell is either to shoot it from the bottom looking vertically up the spiral to a possible skylight at the top or to climb to the top and shoot directly down the full spiral. In either case, if sufficient flash units are available, it is best to illuminate the staircase from a similar position (i.e. out of view on the same side of the stairwell as the photographer) at every level.

Figure 8.14 Shooting a stairwell either from the top looking down or from the bottom looking up can be dramatic. Where possible, try to illuminate the staircase from a similar position at every level

9
Extra effects

Introduction

The previous chapters have established various approaches with a diversity of techniques to enable you to photograph most interiors that you are likely to encounter. By now, you should be starting to feel in tune with the whole process and language of interior photography, from which your own individual approach to interiors can be confidently generated. Within this framework, we can now go a step further and look at some extra effects that can be employed to enhance your images.

Balancing interior and exterior light to show external view

One key feature of an interior can, occasionally, be the view outside the window. This can be an exquisite garden or countryside in the case of a residential interior; or an important view of the rest of the complex from an industrial or commercial interior.

Employing the regular 'fill-in' technique as described throughout this book, whereby the daylight through the window is treated as the dominant light source, will usually cause the view outside any window to be burnt out, i.e. to be so bright as to bleach out much of the colour and detail in the external view. This clearly has its advantages, especially in cities and towns, where the external view often is best burnt out by over-exposure. However, when one wants to retain the rich colours and detail of the view outside, a different balance has to be employed. As one might imagine, this should be based around an approximately equal balance of the interior and exterior light intensity, with a slightly brighter intensity outside than in.

Having determined your working aperture (by either the 'critical precision method' or the 'practical everyday method'), take a light reading from the window of the external view for an aperture half a stop smaller than the working aperture (e.g. $f/27$ instead of $f/22$). This will give you an exposure that will record the external view on film as half a stop brighter than the interior lighting.

The reason for a half stop, or even a full stop, difference between the interior and exterior light intensity is to create on film the most natural appearance possible. We expect the outside view to be brighter than the light level inside, so this produces that illusion without damaging the detail of the view or weakening its colours too much. The exposure required will

Figure 9.1 Balancing interior and exterior light to show the view outside. The view of the tree from this studio room is absolutely integral to the interior. Typically with this technique, it is appropriate to have the outside view about half a stop brighter than the inside light. However, in this exceptional case I felt an even balance was more appropriate. The tree almost appears as a framed picture on the wall to complete the integration of inside and out

be much shorter in duration than we are used to using. This therefore means that the interior will largely be illuminated by a combination of flash and any direct sunshine in the room, rather than by the usual burning in of available light.

If the flash output needs to be built up by firing the flash units more than once, this will have to be done by double, or multiple, exposure. For example, with a working aperture of $f/22$ and a corresponding exposure reading of $\frac{1}{30}$ second (actually taken for an $f/27$ aperture, to produce a brighter external view), a flash with a single output reading of $f/11$ will need to be fired four times (twice to take it up to $f/16$, and double that, i.e. four times, to increase the output for an $f/22$ aperture). In order for the flash to be fired four times, four exposures will be necessary, each at one-quarter the duration of the metered $\frac{1}{30}$ second, i.e. at $\frac{1}{125}$ second (being the calibration on the camera that is approximately one-quarter the duration).

Unless working on a detail area surrounded by windows, you are likely to lose some of the natural atmosphere of the interior that would have been created using the fill-in technique. This is the compromise that must be made if the external view is an important feature to be included in a particular interior.

Creating a night scene

Clients will sometimes ask for a residential interior to be photographed as a night scene, be it a bedroom or living room. This can easily be achieved during the day as Figure 9.2 demonstrates: the night shot being taken immediately after the daytime shot.

With a daytime shot, daylight is likely to be the dominant light source, with subtle fill-in flash to reduce the contrast. Conversely, with a night scene, all daylight must be shut out, and the artificial room lights should appear to be the dominant source, even if the flash is actually dominant. This, therefore, requires the curtains to be drawn and the lights to be switched on. The curtains should preferably be lined to reduce daylight penetration to a minimum.

You will probably also have to alter the position of your flash unit(s) from the daytime shot. You no longer wish to be too directional with your photographic lighting (assuming that you were filling-in from the same direction as the dominant daylight), and further units may need to be added to even out the lighting.

For purposes of the 'practical everyday method', you can use the flash to fully illuminate the interior, burning in just enough of the available light from the tungsten room-lights and lamps to create a natural, warming glow around them without creating too strong a colour-cast. To determine the length of exposure, take light readings for the working aperture from furniture or areas close to the room-lights or lamps in the picture. Because these areas will be brighter than the general level of light in the room, an averaging of these readings should give you a reasonable starting point for shooting an instant-print, with the colour-cast from the lamps not too strong. Increase or reduce the exposure time according to your interpretation of the instant-print.

When more critical colour rendition is required, you will have to use a double-exposure technique (similar to those described in Chapter 7) on

Figure 9.2 A night scene can easily be created in daytime, as these two photographs demonstrate. The night scene was taken immediately after the daytime shot to give the client a choice. Curtains should preferably be lined, and the room lights switched on to appear as the only source of illumination. However, soft and even flash lighting should actually be the dominant light source

tungsten-balanced film. The first part would be a fast exposure for the flash (say, $\frac{1}{250}$ second), with an 85B colour conversion filter over the lens; and the second part, a longer exposure for burning in the available room-lights, without filtration. Use the flash as a strong fill-in light source, perhaps starting off with it at half the strength of the available light instead of the usual one-quarter under daylight conditions.

 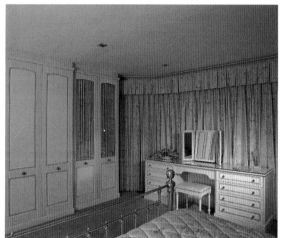

Figure 9.3 These flowers were highlighted with a diffuser attachment to the flash unit, with softer flash lighting bounced off a white umbrella from the left

Highlighting

There are occasions when a significant element or specific area within the interior needs to be subtly highlighted – be it a product within a setting, a painting, or an attractive vase of flowers, for example. You can create highlights of differing shapes and sizes by placing a variety of readily available diffuser and snoot attachments over the flash unit or tungsten lamp. Diffusers concentrate a soft, square light onto a specific area which can be finely controlled and shaped with the use of 'barn doors' (hinged flap attachments to the front of the diffuser). Snoots, on the other hand, create very directional, circular spots of light.

People in interiors

The majority of interiors photographed are empty of people so as to concentrate the eye specifically on the interior detail rather than any people within it. However, people are sometimes integral to the interior, usually in commercial or industrial situations. Magazine features also often like to include a photograph of the individuals within their interiors.

In commercial and industrial situations there are three basic options open to you. The first is to freeze all action within the interior by having people carefully posed to look as natural as possible, even if the suggestion is one of action.

This is a useful technique when either clear identification of the individuals or the processes in which they are involved is an important part of the brief.

Figure 9.4 Freezing the action, by carefully posing people to suggest the action, is one option open to you when dealing with people in interiors

Table 9.1 Neutral density filters

Standard ND Filters	ND filter	Percentage of light transmitted	Exposure factor increase	Actual exposure increase
	0.1	80	× 1.25	⅓ (stops)
	0.2	63	1.5	⅔
ND × 2	0.3	50	2	1
	0.4	40	2.5	1⅓
	0.5	32	3	1⅔
ND × 4	0.6	25	4	2
	0.7	20	5	2⅓
	0.8	16	6	2⅔
ND × 8	0.9	13	8	3
	1.0	10	10	3⅓
	2.0	1	100	6⅔

The standard ND filters are shaded in grey, and are popularly referred to by their exposure factor: ND × 2, ND × 4 and ND × 8.

Figure 9.5 The blurred movement of activity within a static interior can be achieved by using longer exposures, typically between ¼ and 2 seconds. This works especially well when using a combination of flash and long exposure. The flash freezes a clearish outline of the individuals, and the longer exposure captures their movement thereafter.

A more interesting and dynamic approach is to allow the people within the interior to continue their activities. Using exposures between ¼ and 2 seconds, you can capture on film the essence of their activities within an otherwise static interior setting. This works especially well when using a combination of flash and long exposure as the flash freezes a clearish outline of the individuals (depending on how close they are to a flash unit), and the long exposure captures their following movements in a blur of activity. This can be used to great effect, producing some startling images. It enhances the atmosphere of the interior without allowing the distraction of individual personalities within it. This has the added advantage from the point of view of stock photography as it avoids the necessity for model releases before the pictures can be published.

The final option is to actually eliminate on film the recording of the people in the interior, for example in a large busy shop. This is done by using very long exposures with just the available light, so that brief movements in and out of the image area fail to record on film. If the interior is brightly lit, and even with a small aperture the exposure reading is only a few seconds, then you can place a neutral density (ND) filter over the lens. This is a plain, colourless grey filter of a specified factor that reduces the level of light reaching the film by that factor (e.g. NDX2 requires a doubling of exposure), without affecting in any way the colour or contrast of the original image. An exposure of between 30 seconds and a minute should prevent most movement, and therefore people, from being recorded on film. The only people who will be recorded are those who are relatively static for the duration of the exposure. In the example of the busy shop, this could be the sales assistant. Clearly, this should be taken into account when using the technique.

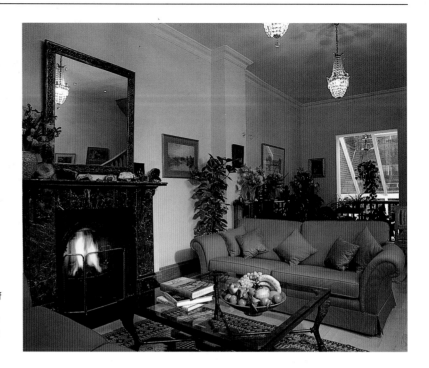

Figure 9.6 A fireplace can be
brought to life by lighting the fire. If
gas is unavailable, burn knotted
newspaper in the grate. The longer
the exposure, the more blazing the
fire appears on film

Illuminating fireplaces

Unless fronted with an interesting firescreen, or elaborate display of dried
flowers, fireplaces in interior photographs can easily appear as dense black
voids due to their matt black, highly light-absorbing, quality. The contrast
of this black void with the rest of the room can be an unsightly blot on the
final image unless brought to life in one of a couple of ways.

The simplest way to bring to life to a fireplace is to light the fire, either
with genuine coal or logs (though these take a long time to glow and can
make conditions unbearably hot in the warmer months); using gas if it is an
artificial log or coal fire (these also need to be left on for a while to glow,
though they are much faster than the real thing); or very simply by burning
knotted sheets of newspaper in the grate. Do not forget to open the flue
when lighting any fire.

Knotted newspaper lights and burns with dramatic flare and intensity for
the short duration of the actual exposure. It is usually possible to manage
two or three exposures with one burn of paper, so to achieve a full roll of
10 or 12 frames it might be necessary to light three or four separate
newspaper fires. The effect is dramatic and usually perfectly appropriate
for the chosen duration of exposure. The longer the exposure, the more
blazing the fire appears on film as a result of the greater recorded
movement of the flames.

The effect of the fireplace can be further enhanced by illuminating the
fireplace area with flash bounced off gold umbrellas. This both adds to the
gold warmth of the firelight and helps reduce the contrast of the deep black
grate.

(a)

(b)

Figure 9.7 Photograph (a) is the essential conventional shot of this commercial reception area. Photograph (b) is an alternative shot, looking down from half-way up the staircase. A creative angle on such an interior can add that spark of excitement that lifts a brochure or display

Figure 9.8 Tilting the camera on its side can exaggerate the graphic impact of an abstract composition

Figure 9.9 Photographing an element of the interior from an oblique angle can add a dramatic abstraction to a potentially dull shot

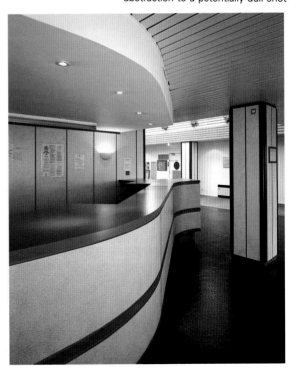

Creative angles

Many modern interiors, notably commercial reception areas in my experience, lend themselves to photographic interpretation in a number of different ways. There are always the essential conventional shots to be taken, showing the full scope of the interior from approximately eye-level. However, around these base shots, further experimental shots taken from novel and creative angles can be tried.

The client will always want to see the conventional shots as they are the all-important informative photographs, the mainstay of the feature or brochure. They are also the safeguard that allow you to experiment with different approaches once they have been taken.

A high vantage point often throws an interesting perspective on an interior. Maybe this can be done from one or two floors up an atrium, or from half-way up the staircase as in Figure 9.7. Overlooking an interior from a high viewpoint renders a more abstract composition. So exploit the abstraction, forget about lens shifts and allow the verticals to diverge to the full. Try tilting the camera on its side by 45° to add further dynamism to the lines within the composition. Treat the whole exercise as a creative process of abstract picture composition while incorporating the essential elements of the interior.

Another approach is to photograph an element of the interior from an oblique angle for dramatic and more abstract composition as, for example, the reception desk in Figure 9.9. You can also try shots from very low angles, especially if an interesting ceiling or atrium skylight is an integral part of the interior.

Depending on the client, the purpose for which the photographs are being taken, and the success of your experimentation, a semi-abstract interior photograph taken from an unusual, creative angle can often be that imaginative spark that lifts the whole tone of a brochure or display. Furthermore, it stretches the imagination and creative ability of the photographer, and can provide stunning, eye-catching images for a portfolio.

10
Presentation

Introduction

While the quality of the photographs themselves is of paramount importance, be they colour transparencies or prints, the significance of their presentation cannot be overstated. An excellent set of photographs poorly presented to a busy editor probably stands the same chance of publication as an average set of photographs beautifully presented.

The level of attention paid to presentation of the final images is subconsciously taken by the client to be a reflection of the overall attitude, professionalism and quality of the photographic work itself. A client who regularly receives good results from you, edited and presented in a consistently clean, clearly marked and efficient manner, is more likely to call you for that all-important next assignment than the photographer who presents photographs in disorderly array, stuffed into a scruffy re-sealed packet from the laboratory. The latter is inevitably viewed as indicative of a sloppy, uncaring attitude which the client is likely to mentally attach to his or her work, be that true or false.

Editing

Editing is primarily a selection procedure, but it should also be used as a constructive process of education. When faced with the sheet or roll of transparencies on a lightbox, exposure comparisons and lighting ratio variants become clear, especially if you made a written record of exposure and lighting details at the time of the photography. The focus and colour accuracy should be checked, and if any consistent problems occur, a remedy must be worked out. Use a high-quality magnifier to scrutinize the images to the full.

Editing a sheet of transparencies can be done in one of two ways. You can either edit out the significantly over- or under-exposed frames, plus any that are damaged physically of visually, or you can edit the best transparencies for mounting prior to presentation.

Your choice of method will be determined by what you think your client will want to see. Most commonly with interior photographs, it is best to edit out any poor frames and present the client with a set of images of each shot, with slightly differing variations in the lighting ratios. This will give the client the opportunity to select a preferred lighting ratio and precise exposure, without imposing your personal preference.

Some less experienced editors appreciate the photographer's advice on the most suitable transparency for reproduction. If this is the case, you can mark your preference with a small cross on the acetate sheet in which the transparencies are simply mounted by the laboratory, using a chinagraph crayon. Chinagraph crayons are soft and waxy, and come in a variety of colours. They write easily on acetate without damaging the transparencies within, and their marks can be easily wiped off with a soft cloth, or even a finger, if no longer wanted. This method allows the editor to also view the unselected transparencies to be reassured that you have chosen the most suitable ones.

In editing out the poor transparencies we must physically cut out any that are clearly unacceptable. This will effectively reassure your client of your consistent results, as well as improving your presentation. In doing this, or at any time you are directly handling the transparencies or negatives, it is best to wear soft, lint-free cotton gloves to protect the films from fingermarks. If you do have to handle them with bare hands, ensure that you only ever handle them by the edges, and that your hands are freshly washed and properly dried. Fingermarks are difficult to remove from transparencies or negatives without causing further scratch damage, so handling films with bare hands should be avoided wherever possible.

First, cut out any transparencies that are physically or visually damaged. Despite the excellent and consistent processing produced by commercial laboratories, small creases, scratches or chemical stains do damage the occasional frame from time to time (see the next section on 'Film damage' for details). The odd frame will also inevitably be shot either without the flash cable attached or with a person unexpectedly walking through a door within your picture area during an exposure. This is what is meant by 'visual damage'.

Figure 10.1 The editing and mounting of transparencies should be done on a lightbox, using a freestanding magnifier for critical viewing. Mark up the sheet with a chinagraph crayon, then cut out the individual transparencies and mount them in black mask transparency sleeves, using permanent clear tape

Next, cut out the significantly over- and under-exposed frames. There might be a couple out of the 10 or 12 frames like this, but hopefully not more than that.

Finally, you may wish to edit a further image for the purposes of your portfolio. Assuming your sheet of transparencies is possibly reduced to seven or eight frames from an original ten, there should be plenty of good images within the set to make this possible. Such a practice can be easily overlooked or ignored at busy times, but once delivered to the client, you are unlikely to see those transparencies again.

If you choose to edit the best transparencies for mounting prior to presentation, or by marking the sheet of transparencies with a chinagraph crayon to advise the editor, you have to be very particular in your selection. Selecting transparencies for reproduction might sound simple, but it actually requires great care and consideration.

Use a lightbox, preferably with fluorescent tubes colour-corrected to 5500 K, to enable you to view at least one full sheet of transparencies at a time. Even if just editing the transparencies for subsequent mounting, use a chinagraph crayon at this stage to mark selected transparencies prior to cutting them out. This will allow comparison of transparencies on different sheets if the pictures are to form a consistent set, before finally committing them to the scissors.

To the inexperienced eye there is often a tendency to select an image that is bright and light. However, the lighter the transparency, the weaker the colour saturation. Conversely, the darker the transparency, the richer the colour saturation which, obviously within limits, is better for reproduction (and certainly for duplication). It is impossible to enrich colours in a very light transparency (over-exposed), but it is possible at the reproduction stage to boost the brightness of a darker transparency with richer colour

Figure 10.2 An example of film damage at the time the photograph was taken. A hair was trapped in the film plane causing its image to appear on film. This can be an expensive fault to rectify in terms of retouching costs, as it is likely to appear on every frame of the film. The regular dusting and cleaning of your equipment should keep this type of damage to a minimum.

saturation (under-exposed). It is also possible to make a brighter duplicate transparency from a darker original, but not the other way round. Selecting the preferred lighting ratio variant should be based primarily on what looks the most natural and appropriate on the final transparency as well as on your experienced knowledge of the preferences of your client.

Film damage

As mentioned in the previous section, film damage does occur from time to time. I am using the term 'film damage' to cover any physical damage to the final image, be that in the manufacture of the film, the taking of the photograph, or, more commonly, at the processing stage. Its unpredictable occurrence is another good reason for shooting a full roll of film on each different subject to allow for the possibility of losing the odd frame to such damage.

The worst possible type of film damage that can occur is when the whole film is ruined, rendering all the images of a particular subject unusable. This can happen as a result of a rare manufacturing fault; as a continuous fault at the time of exposure; or as a result of a film falling from its hanger during development at the processing stage.

Fortunately, manufacturing faults are very rare as all film batches are tested by the manufacturer prior to sale. In ten years I have experienced only two, both by leading film manufacturers. One was a 35 mm roll of colour transparency film that was literally without emulsion apart from a couple of frames at either end. The middle 20 frames were a strip of completely clear acetate. The other was a 35 mm black-and-white film that was littered with small scratches over its full length. When such cases can be proved to be manufacturing faults, the major film manufacturers are

Figure 10.3 An example of a processing fault. The small, black, crescent-shaped mark on the transparency is caused by a small crease on the film. When such damage occurs, it usually only affects one frame on the roll

sometimes willing to pay compensation for having to repeat a job, at your current rate, beyond their legal liability just to replace the film.

Film damage that can occur at the time the photograph is taken includes 'fogging' (when the film is accidentally and unknowingly partially exposed by ambient light) if the film is loaded or unloaded in too bright conditions; fogging from any small light leaks within the camera; or more commonly, the image of a hair or other obstruction trapped in the film plane, appearing on the film.

To overcome the problem of fogging when loading or unloading the film from the camera, always make sure this is done away from direct sunlight. Also, with roll film, ensure that the backing-paper is as tightly wrapped and sealed around the exposed film as possible. With due care, fogging is a rare problem.

A hair, or other obstruction trapped in the film plane is more difficult to control, other than to keep all your camera equipment as clean and dust-free as possible. This means regularly dusting off and cleaning lenses, the interior of the camera, and especially the interior of the film backs. Needless to say, extreme care should be exercised in all such cleaning operations. The backing-paper in a roll film prevents dirt from scratching the film on the pressure plate in the film back as it is wound on, but small pieces of dirt caught on the side of the film surface can lead to costly retouching bills.

Processing faults are more common than manufacturing faults, but usually less drastic unless, as already mentioned, the film actually falls from its hanger during the processing. They come in a variety of recognizable forms: small creases that render a small black crescent-shaped mark on one frame of the transparency when processed; chemical stains, most often yellow, that damage only one or two frames; or small white scratch marks which have occurred, for whatever reasons, while the emulsion was in its vulnerable, wet state. Over- or under-development is another potential processing fault, and this can be readily checked visually by direct comparison of the pre-exposed manufacturer's numbering on the suspect film with that on a previous correctly developed film. If the numbering appears weak, this would suggest under-development; if it is very bright, heavy and woolly, over-development.

The most fool-proof system a photographer can adopt to insure against the possibility of film damage is to shoot a few extra frames of each subject on a separate film, using a different film back. If the original films are undamaged, the spare film can be confidently thrown out without the expense of having it processed. This can be a small price to pay compared with the inconvenience, disruption, embarrassment and cost of reshooting should any drastic damage occur. It can also provide you with a further source of images for your portfolio should you need them.

Mounting

Having selected the best transparencies for either your client or portfolio, and cut them out as individual images from their film strips, it is time to mount them prior to presentation or storage. Both editing and mounting are most easily and neatly performed on a lightbox. It enables you to have a clear view of the transparency for perfectly aligned mounting.

The most popular method for mounting transparencies, especially those larger than 35 mm, is to mount them in black mask transparency sleeves.

Figure 10.4 Published material for your portfolio can be mounted on black card and laminated. This both enhances its appearance and protects it from becoming fingered, creased and scuffed

The masks are made of folded black card with precision-cut frames for the transparency size chosen. The mask is opened like a greeting-card and the transparency aligned inside the mask, If, for any reason, the image on the film has been taken slightly off-square, there is usually just enough room within the mask frame to twist the transparency round a fraction to make the final presented image appear perfectly squared off. The transparency is then taped in position along one side with a small piece of permanent clear tape. Permanent tape differs from regular adhesive tape in that the glue it uses never deteriorates into a potentially damaging sticky mess. It should readily peel off the transparency at any time in the future. The tape must be stuck only to the very edge of the black transparency frame, and should

under no circumstances cover any part of the actual image. This will provide a quite sufficient anchor for the transparency and minimize interference with it.

The mask is then closed creating an attractive, black frame around the image. This enhances the whole appearance of the photograph. The photographer's personal adhesive label (with details of name, address and telephone number) can next be stuck to this black frame. This should both ensure it never gets lost and also act as a useful reference for the editor if he or she wants to publish the image with a credit alongside. The mask is then placed in a clear acetate protective sleeve, with a frosted matt back to diffuse the light passing through it. This enables the mounted transparency to be viewed clearly both on a lightbox and when held up to any available light source. The matt back prevents any distraction from the possible view of the light source behind it, be that a window or domestic tungsten lamp.

Figure 10.5 The black mask transparency sleeve. The transparency is taped in position along one side with a small piece of permanent clear tape, taking care not to cover any part of the actual image. The mask is then closed like a greeting-card, the photographer's personal adhesive label stuck on the front, and the mask placed inside a protective acetate sleeve

Presentation to client

The transparencies are now edited, and mounted either in black mask transparency sleeves or in the clean acetate sheets from the laboratory. Both are perfectly acceptable ways of presenting images to clients. It may be necessary to mark the different images or sheets with reference numbers relating to typed details on a separate sheet of paper. It is certainly necessary to mark the envelope with details of the contents, and to clearly print the client's name and address.

The envelope should always be new, of a size to match the contents, and card-backed to protect the transparencies or prints. It is useful to your client's receptionist if you place one of your personal adhesive labels on the reverse of the envelope as an indication as to who the package has come from. It is also courteous to include a compliments slip with the pictures. If the photographs are to be posted, or delivered by messenger, it is also sensible to ensure there is a 'Photographs – Do Not Bend' warning stamp on the front of the envelope. It should go without saying that all posted photographs should be sent first class, and by recorded delivery if you want proof of their receipt.

Portfolio

A portfolio is your own, very personal, advertisement to potential clients. Its purpose is to impress potential clients so much that they choose you for their future photographic requirements. It must, therefore, be the best possible presentation of the best possible images you have taken in the area of interest of your potential client. It also helps if you take along a selection of publications in which those images have appeared, to give added credibility to your success and, therefore, suitability.

Your portfolio should be carefully created from your stored work back at base, each time tailoring it specifically to the likely requirements of that potential client. It is much better to show a few quality images in the client's likely area of speciality than a vast range of all the photographs you like best from your full collection.

There are various methods of displaying your portfolio, and your choice will depend both on preference and budget. These range from an expensive briefcase lightbox to a simple plastic carrying case. The advantages of the briefcase lightbox are that it is both the smartest way to transport your transparencies and gives you the confidence that they will be properly displayed whether or not your potential client has a lightbox available. Again, it also helps convey an overall impression of quality and efficiency.

Within such a briefcase, or other carrying case of your choice, your transparencies should be mounted in black mask transparency sleeves either singly or in carefully selected groups. Both A3 or A4 sized black mask transparency sleeves are available for mounting a quantity of transparencies on a single sheet, typically between two and 12 for medium-format transparencies.

If you decide not to purchase a briefcase lightbox, and there is no lightbox available, transparencies can be adequately viewed by holding them up to a window. A small, inexpensive standby measure might be to carry a battery operated mini-lightbox with you, available with a screen size of 5 in \times 4 in.

Published material should form the other part of your portfolio. This can either be presented in its raw state as the brochure or magazine feature that it is or can be selectively edited, mounted on black card and laminated. Lamination protects the material from becoming fingered, creased and scuffed, and keeps it looking its best for longest. The mounting on black card, an A4 size image on A3 size card, for example, gives the material a feeling of selective importance, with the black framing giving the image more impact, just as with the transparencies mounted in black mask transparency sleeves. The laminates or raw published material can be transported and presented from a smart art case. If you have no published work do not be put off. High-quality transparencies or prints can respectably stand alone.

It is also sensible to have a photographer's card with your name, address, telephone number and a selection of your best images to leave with the potential client as a permanent reminder of your work. A few printers and laboratories specialize in this kind of work, so for the highest quality service and best advice it is best to go to one of these specialists. If such a presentation card is beyond your budget, at least have some smart business cards printed.

Finally, because a portfolio presentation is about both your work and you as a photographer, your personal presentation and efficiency will also be

under scrutiny. Dress smartly, at least casually smart, and be on time for your appointments. Having a scruffy appearance and arriving 10 minutes late for an appointment will inevitably undermine your presentation, however good your work.

Storage

The main prerequisites for archival storage are to store your photographic images in darkness and in acid-free materials, in such a way that they can be easily retrieved. Three elements are involved in this process: first, the best method and the most stable materials for storing individual transparencies or negatives; second, the most practical and efficient system for filing these transparencies and negatives; and third, the most suitable storage container for the filed material.

By their very nature, transparencies and negatives have to be treated in different ways for the first two stages. Because individual transparencies can be readily identified on a lightbox, it is customary to mount the best one or two as described in the earlier section on 'Mounting', and store the remainder separately in case of possible future use. Commercially produced black mask transparency sleeves should be of reasonable archival quality for storage, and protect the transparency from dust and scratches.

Negatives, however, be they colour or black-and-white, are best identified from viewing a contact print in a file, and then drawing out the relevant negative from its file by use of a corresponding reference number. The negatives themselves should be stored in negative bags: preferably A4-size with ringbinder holes for simple file storage. Such negative bags are made of acid-free translucent glazed paper, and are divided up to hold a full film of individual negative strips in one sheet, from which the corresponding contact print is made.

All mounted transparencies and filed negatives should be captioned, dated, and/or numbered depending on your personal choice of filing system. Negatives are probably most simply filed by number in separate files according to subject matter. Their corresponding contact prints can be filed in a similar way, with relevant captions and dates for reference.

Transparencies are also most efficiently filed by subject matter and number, and, depending on the quantity of each subject, can be subdivided any number of times to keep each file to a manageable size. For example, general commercial photographers may have a file for architecture, one for portraits, another for travel, etc. As they start to specialize in architectural photography, they can split their architecture file into two: exteriors and interiors. As these shots build up, they can further subdivide their filing system. Both exteriors and interiors can be divided into commercial, residential and communal. If further divisions are necessary, exteriors can be broken down into traditional and modern categories; interiors into room-types within the commercial, residential and communal categories. A system of cross-referencing may be important if individual images are subdivided away from others taken of the same building. This is where the numbering is important for transparencies. All divisions, subdivisions and numbering should be recorded in a separate file or on computer.

It may be more relevant to your personal requirements to file all shots of a particular building together, rather than to subdivide them into different categories. If this is the case, this can either be done numerically (perhaps

by job number) or alphabetically, again with written details on file for quickest access.

Once you have worked out a suitable filing system you must turn your attention to the problem of the physical storage of all your transparencies and negatives. As mentioned earlier, negatives can be filed in commercially produced negative files, kept in sequence on a shelf. They can alternatively be stored in metal-tray drawer cabinets, which are also very suitable for storing transparencies.

Transparencies can be mounted for filing in a standard metal filing cabinet or housed in enclosed plastic trays within a commercially designed transparency storage cabinet. Storage should not be in wooden or cardboard boxes in case acids within them start to deteriorate the emulsion. One final note of caution: keep all negatives and transparencies out of direct sunlight at all times, and in darkness as much as possible. Try to avoid the frequent projection of transparencies, and if this is impossible make duplicates for such purposes.

Bibliography

Buchanan, Terry (1984) *Photographing Historic Buildings*, Her Majesty's Stationery Office.

De Sausmarez, Maurice (1983) *Basic Design*, The Herbert Press.

Freeman, Michael (1990) *Collins Photography Workshop: Film*, Collins.

Freeman, Michael (1990) *Collins Photography Workshop: Light*, Collins.

Freeman, Michael (1981) *The Manual of Indoor Photography*, Macdonald.

Hawkins, Andrew and Avon, Dennis (1984) *Photography: The Guide to Technique*, Blandford.

Langford, Michael (1989) *Advanced Photography*, Focal Press/Butterworth-Heinemann.

Langford, Michael (1986) *Basic Photography*, Focal Press/Butterworth-Heinemann.

McGrath, Norman (1987) *Photographing Buildings Inside and Out*, The Architectural Press.

Petzold, Paul (1977) *The Focal Guide to Lighting*, Focal Press.

Pinkard, Bruce (1985) *Indoor Photography*, Batsford.

Index

Action:
 people, 85
Advertising, 47
Angles:
 creative, 87–88
Aperture:
 bracketing, 52
 capturing exterior views, 81–82
 critical precision, 55–57
 depth of field scale, 49, 50
 metering, 50–51
 multiple exposure, 57
 reciprocity failure, 28
 swings and tilts, 11–12
Architects, 44
Architectural photography, 9
Available light, 41 *See also* Daylight
 balanced with flash, 51
 burning in, 74
 focusing, 50
 large interiors, 67–68
 sunlight, 74–75

Barn doors, 22, 83
Basic Design (de Sausmarez), 38
Bellows:
 displacement, 56
Black and white film, 27, 31–32
 contrast, 32
Bracketing:
 practical method, 52
 v. clip tests, 72
Burning out, 1
 available light, 74
 unwanted views, 81
Business cards, 96

Cable releases, 25, 69
Camera position:
 assessing rooms, 36
 lighting, 42
 reflective surfaces, 76–77
 small interiors, 73
 tripods, 48
 walls, 37
Cameras, 4, 5–12
 care and handling, 93
 choosing quality, 5
 collectable, 5
 interchangeable backs, 6, 12, 32–33
 large format, 6

Cameras – *continued*
 loading, 93
 medium format, 6
 movements, 8–11
 spirit livels, 12
 view, 55–57
 viewcameras, 6–12, 33, 55–57
Chinagraph crayons, 90
Churches:
 large interiors, 67, 68, 69
 painting with light, 70–71
Clients *see also* Presentation
 practical method and, 47
 requirements, 44
Clip testing, 72
Close-up and detail shots, 44–45
Colour balance:
 checking, 59–60
 film age, 28
 night scenes, 82
Colour compensation filters, 17
 chart, 65
Colour correction, 29
 exposure calculation, 57, 58
 filters, 15–17, 55
Colour saturation, 91–92
Colour-temperature meters, 15, 24, 59
Colour temperature scale, 15–17
Commercial work:
 camera variety, 5
Company of Cutlers, x, 1–4
Compasses, 35, 75
Composition, 1, 36–40
 abstract, 87, 88
 creating space, 39, 40
 dynamic images, 1, 38, 53
 framing, 39, 40
 image construction, 53
 individual interpretation, 38
 Law of Thirds, 36–37, 53
 perspective, 39
 spatial values, 37
 stairs, 79
 symmetry, 36
 viewcameras, 7–8
Contract print files, 97
Contrast, 1, 32
Convergence *See* Perspective
Creativity:
 angles, 87–88
 individual interpretation, 38
Credit lines, 95
Curtain and blinds, 62–63

Daylight, *See also* Available light
 assessment of room, 35–36
 checking colour balance, 59–60
 creating with filters, 78
 creating with tungsten, 22
 flash fill, 19
 instant-print film, 32
 mixed with fluorescent, 65–66
 poor conditions, 78
 pratical lighting, 48
 replacing electricity, 76
 temperature, 16–17
 tungsten mix, 61–64
Depth of field:
 calculators, 57
 camera size and, 6
 Linhof Universal table, 56
 scale, 49, 50
Detail (close-up) shots, 44–45
Details and Style, 40–41
Diffusion, 83
Divergence *See* Perspective
Dunn, William, 31
Dynamic image, 1

Editing, 89–92
Editors, 44
Effects:
 capturing exterior views, 81–82
Electricity:
 working without, 76
Empty interiors, 74–75
Equipment:
 camera size and, 6
 filters, 15–19
 lighting, 19–23
 meters, 23–24
 necessary extras, 25
 tripods, 24–25
Etiquette, 60
Exposure, 4 *See also* Film speed; Instant-
 prints; Reciprocity Law
 black and white flexibility, 31
 bracketing and trials, 52, 54
 calculating for multiple, 57
 clip test v. bracketing, 72
 critical precision method, 57–59
 filter factors, 18, 29, 62, 65, 84
 instant-print to transparencies, 57–59
 multiple for mixed light, 61–66
 over- and under-, 91–92
 painting with light, 69–72
 reciprocity, 28
Extension cables, 25
External views, 81–82

Factories:
 large interiors, 67
Filing, 97–98
Film, 4, 27–33 *See also* Reciprocity Law
 batch numbers, 28–29
 black and white, 31–32

Film – *continued*
 choosing, 27
 colour negative, 30–31
 colour transparencies, 29
 contrast, 32, 41
 critical precision choice, 55
 damage, 92–93
 daylight and tungsten balance, 17
 daylight v. tungsten, 29
 instant-print, 32–33
 loading, 93
 practical choice, 50
 Professional, 28
 storage, 28–29, 97–98
Film format, 4
 35 mm not suitable for interiors, 5
 actual size diagram, 7
 bracketing, 6
Film speed, 27
 black and white film, 31
 colouring, 30
 instant-print film, 32
 transparencies, 29
Filters, 15–19
 colour balancing, 59
 colour compensation, 17–18, 65
 colour correction, 15–17, 18, 23, 29, 55
 creating daylight, 78
 daylight with tungsten, 17, 61–64
 diffusion, 83
 exposure factor, 18, 29, 62, 65, 84
 fluorescent and tungsten, 64–65
 fluorescent light covers, 66
 mired shifts, 17
 mounts, 18–19
 neutral density, 69, 84, 85
 night scenes, 83
 tungsten light, 17, 23, 61–65
 types, 15
 window gelatin, 64
Fireplaces, 86
Flash:
 ancillary equipment, 21
 exterior views, 82
 filling in, 41–43, 62
 fireplace, 86
 flashguns, 19
 hiding in large areas, 68–69
 integral unit, 20–21
 metering, 24
 multiple exposures calculation, 57
 night scenes, 82–83
 painting with, 69–72
 portability, 76
 practical method, 48–49
 small rooms, 73–74
 studio power pack, 20
Flash meters, 24
 practical method, 50
Flash-synch cables, 25
Flowers and fruit, 40
Fluorescent light,
 checking colour balance, 59
 filtering, 18
 mixed with daylight, 65–66
 mixed with tungsten, 64–65

Focusing:
 critical precision, 55–57
 depth of field scales, 50
 viewcameras, 7
Fogging, 93
Freezing action, 85
Fuji FP-100C, 32
Fuji Fujichrome, 29
Furniture:
 continuity, 45
 detail shots, 44
 lighting, 49
 spatial values, 37
Fuses, 25

Gloves, 90
Gobos, 23
Grain, 27
 black and white film, 31
Grey card, 50

Highlighting, 83

Incident light,
 colour temperature, 24
 light meters, 23
 practical metering, 50
Industrial warehouses:
 large interiors, 67–68
Instant-prints, 32–33
 assessing lighting practically, 51–52
 camera backs, 6, 32–33
 checking exposures, 6, 72
 checking flash, 21
 checking lamps, 63–64
 exposure calculation for film, 57–59
Insurance, 60
ISO values *See* Film speed

Kelvin degrees, 15–17
Kodachrome, 29
Kodak E-6, 29
Kodak Ektachrome, 29

Lamps *see also* Tungsten light
 night scenes, 82–83
 on or off?, 44, 48, 62
 outside sun, 78
 tungsten balance, 63–64
 tungsten equipment, 22
 warmth, 60, 64
Landscape composition, 36
Large interiors, 67–72
Law of Reciprocity *See* Reciprocity Law
Law of Thirds, 1, 36–37
 practical image construction, 53
Lenses:
 depth of field scale, 49, 50
 linear distortion, 13

Lenses – *continued*
 perspective, 7, 53
 practical complement, 12
 practical shoot, 48
 small interiors, 73
 testing, 12–14
Lifestyle:
 details reveal, 40–41
Light:
 colour temperature scale, 16
 painting, 76
Light meters, 15, 23–24
 incident readings, 23
 metering direct sunlight, 74–75
 painting with light, 71
 practical method, 50
 spotmeters, 23
Lightboxes, 90, 91, 93
 briefcases, 96
Lighting, 1, 15, 19–23 *See also* Flash;
 Umbrellas
 available light, 41
 barn doors, 22, 83
 colour balance, 59–60
 colour compensation, 18
 colour correction, 18
 continuity, 44–45
 diffusers, 21, 83
 film contrast, 32
 flash basics, 19–21
 floodlights, 22
 gobos, 23
 hidden flash, 68–69
 highlighting, 83
 large interiors, 67–72
 mixed daylight and fluorescent, 65–66
 mixed daylight and tungsten, 61–64
 mixed fluorescent and tungsten, 64–65
 mixed interior and exterior, 81–82
 natural look, 51, 78
 painting with, 67, 69–72
 placement, 42
 practical method, 48–50
 reflectors, 22
 small rooms, 73–74
 snoots, 21, 83
 spotlights, 22
 tungsten, 19, 22–23
 umbrellas, 21
Linear distortion, 13, 48
Linhof Technikardan, 7
Linhof Universal Depth of Field table, 56

Magazines, 44
 lamps policy, 62
 people, 84
Masking:
 windows, 62–63
Masking tape, 25
Masks for transparencies, 93–95
Meters *See* Colour-temperature meters;
 Flash meters; Light meters
Mired shifts, 17
Mirrors, 77
 cross-shifts, 8–9

Monorails, 6
Mounting, 93–95
 for storage, 97
Multiple exposures:
 fluorescent and daylight, 65–66
 mixed daylight and tungsten, 61–64
 mixed fluorescent and tungsten, 64–65
 night scenes, 82–83
Mursley Church, 70, 71

National Monuments Records, 31
Neutral density filters, 69, 84, 85
Night scenes, 82–83
Nissan European Technology Centre, 35

Offices:
 empty, 74–75
 large interiors, 67

Paper, 27, 30
People, 84–85
 eliminating, 85
 portrait composition, 36
Personal presentation, 96–97
Perspective:
 camera movements, 8–10
 composition, 39
 convergence, 9, 79
 creative images, 88
 divergence, 7
 empty open plan rooms, 74–75
 lens selection, 48
 lenses, 7, 53
Pillars, 74–75
Polaroid Polacolor 64 Tungsten, 32
Polaroid Polacolor Pro 100, 32
Portfolios, 96–97
Postal delivery, 95
Presentation:
 editing, 89–92
 mounting, 93–95
 personal, 96–97
 portfolios, 96–97
 preparation for posting or delivery, 95
Printing:
 colour balance, 30
Processing:
 black and white film, 31–32
 clip testing, 72
 colour negatives, 31
 commercial labs, 27
 film damage, 92, 93
 over- and under-, 93
 pulling and pushing, 72
 transparencies, 29
Professionalism, 60
 credit lines, 95
Property agents, 40, 44, 47
Publication:
 portfolio presentation, 96

Reciprocity Law, 28
 colouring, 30
 graph, 28
 painting with light and, 69
 practical choices, 50
 transparencies, 29
Reflective surfaces, 76–78
Reflectors, 22

Safety, 60
de Sausmarez, Maurice:
 Basic Design, 38
Scheimpflug adjustments, 8, 11–12, 56
Sharpness *see* Focusing
Shooting:
 assessing rooms, 35–36
 checking equipment, 33
 critical precision method, 55–60, 61
 practical method, 47–54, 61, 82
Shutters:
 long exposure, 69
Single-lens reflex cameras, 6
Slides *See* Transparencies
Small interiors, 73–74
Snoots, 18, 83
Socket adaptors, 25
Sodium vapour light:
 filtering, 18
Space:
 creating, 39, 40
 empty interiors, 74–75
 large interiors, 67–72
 small interiors, 73–74
Spexhall Church, 70
Spirit levels, 12
Staircases and stairwells, 79
Storage, 97–98
Style and detail, 40–41
Sunlight:
 keeping film out of, 98
Sunshine:
 as furniture, 74–75

Tape:
 mounting, 94
35 mm film:
 not suitable for interiors, 5
Transparencies:
 calculating exposure from instant-prints,
 57–59
 colour saturation, 91–92
 editing, 89–92
 handling, 90–92
 light v dark, 91–92
 mounting, 93–95
 portfolios, 96
 practical choice, 50
 storage, 97–98
Trinity College, Cambridge, 31
Tripods, 24–25
 camera position, 48

Tripods – *continued*
 film choice and, 27–28
 viewcameras, 8
Tungsten light:
 critical precision choice, 55
 instant-print film, 32
 lighting equipment, 22–23
 mixed with daylight, 61–64
 mixed with fluorescent, 64–65
 simulating natural light, 78
 temperature scale, 16

Umbrellas, 21
 fireplaces, 86
 hidden flash, 68, 69
 position, 48
 reflections, 76, 78
 small rooms, 73–74
Universal depth of field tables, 56–57

Viewcameras, 6
 bellows displacement, 56
 focusing, 7, 55–57
 instant-print shots, 33
 perspective, 7
 Scheimpflug adjustments, 8, 11–12, 56
 shift movements, 8–10
 swing movements, 11–12
 tilt movements, 11–12
Visual damage, 90

Walls:
 camera position, 37
Wide-angle lenses:
 distortion, 13–14, 48
 practical complement, 12
Windows and glass, 62–64, 77
 capturing the view, 82
 gelatin, 64